Arts of
Southeast Asia

FROM THE POWERHOUSE MUSEUM COLLECTION

CHRISTINA SUMNER
WITH MILTON OSBORNE

ph**m** powerhouse publishing

First published 2001
Powerhouse Publishing, Sydney

Powerhouse Publishing
part of the Museum of Applied Arts and Sciences
PO Box K346 Haymarket NSW 1238 Australia
The Museum of Applied Arts and Sciences incorporates
the Powerhouse Museum and Sydney Observatory.

Editing: Rowena Lennox
Design: Rhys Butler; cover design concept
by Colin Rowan, Powerhouse Museum
Photography: unless otherwise stated, Powerhouse
Museum Photography Section (Penelope Clay, Scott
Donkin, Andrew Frolows, Marinco Kojdanovski, Jean-
François Lanzarone, Sue Stafford)
Project management: Julie Donaldson, Powerhouse
Museum
Printing: Inprint Pty Ltd
Produced in Scala and Mrs Eaves in QuarkXPress

National Library of Australia CIP
Sumner, Christina.
Arts of Southeast Asia: from the Powerhouse
Museum collection
Bibliography.
ISBN 1 86317 085 5
1. Powerhouse Museum - Exhibitions. 2. Art,
Southeast Asian. I. Osborne, Milton, 1936- . II.
Powerhouse Museum. III. Title.
709.59

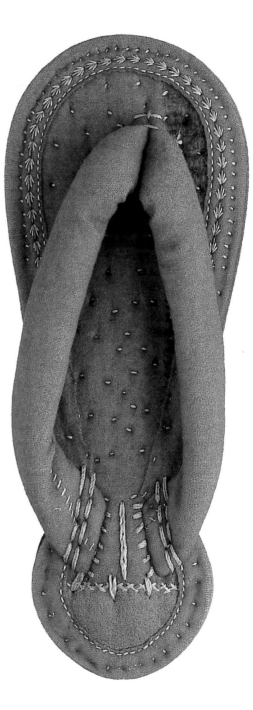

The authors would like to thank Melanie Eastburn for
her major contribution to all stages of this publication.
We would also like to thank Sylvia Fraser-Lu, Pamela
Gutman, Barbara Leigh, Robyn Maxwell, Ann Proctor,
Claire Roberts, Yuri Takahashi and Peter Worsley
for generously sharing their expertise; and Mali
Petherbridge who provided invaluable administrative
assistance.

Published in conjunction with the exhibition *Trade
winds: arts of Southeast Asia* curated by Christina
Sumner with Melanie Eastburn at the Powerhouse
Museum 15 November 2001 – October 2002.

Cover image: Rain cloak from Kalimantan,
Indonesia, 1960–1980 (*see page 51 for details*)

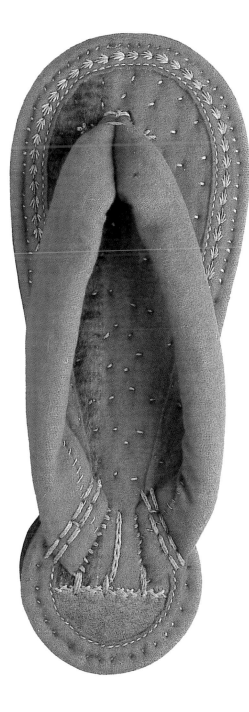

CONTENTS

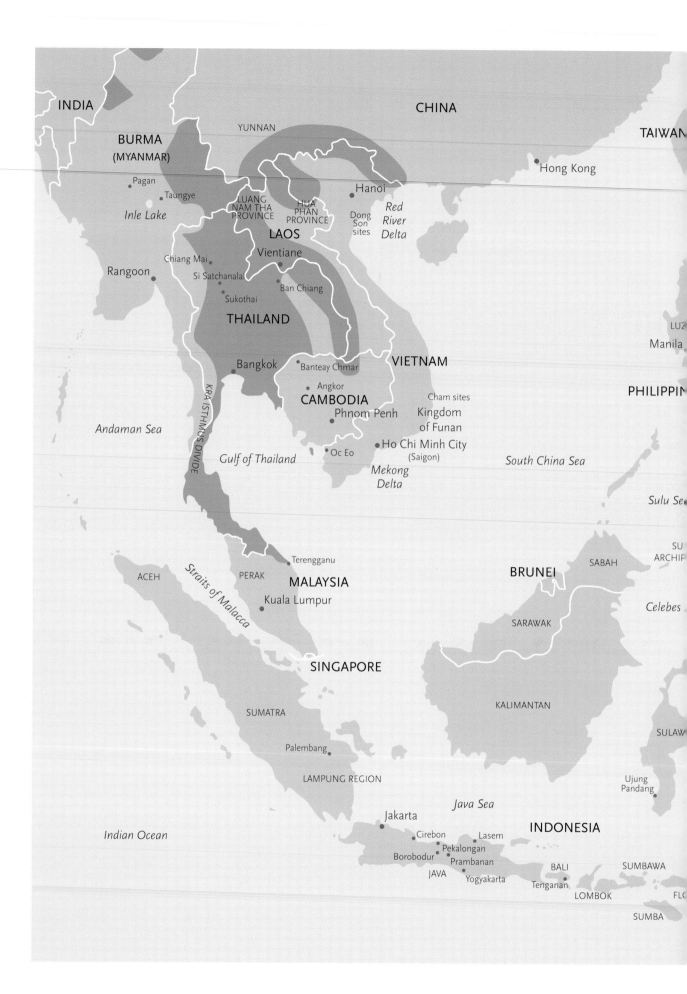

INDIA

BURMA
(MYANMAR)

CHINA

TAIWAN

YUNNAN

Hong Kong

Pagan

Taungye

Inle Lake

Hanoi

LUANG
NAM THA
PROVINCE

HUA
PHAN
PROVINCE

Dong
Son
sites

Red
River
Delta

LAOS

Chiang Mai

Vientiane

Rangoon

Si Satchanalai

Ban Chiang

Sukothai

THAILAND

LUZ

Manila

Bangkok

Banteay Chmar

VIETNAM

Angkor

PHILIPPIN

CAMBODIA

Cham sites

Phnom Penh

Kingdom
of Funan

KRA ISTHMUS DIVIDE

Andaman Sea

Oc Eo

Ho Chi Minh City
(Saigon)

South China Sea

Gulf of Thailand

Mekong
Delta

Sulu Se

SU
ARCHIP

Terengganu

SABAH

BRUNEI

ACEH

PERAK

MALAYSIA

Straits of Malacca

Kuala Lumpur

Celebes

SARAWAK

SINGAPORE

KALIMANTAN

SUMATRA

SULAW

Palembang

LAMPUNG REGION

Ujung
Pandang

Java Sea

Jakarta

INDONESIA

Indian Ocean

Cirebon

Lasem

Pekalongan

Borobodur

Prambanan

BALI

SUMBAWA

JAVA

Yogyakarta

Tenganan

LOMBOK

FLC

SUMBA

SOUTHEAST ASIA

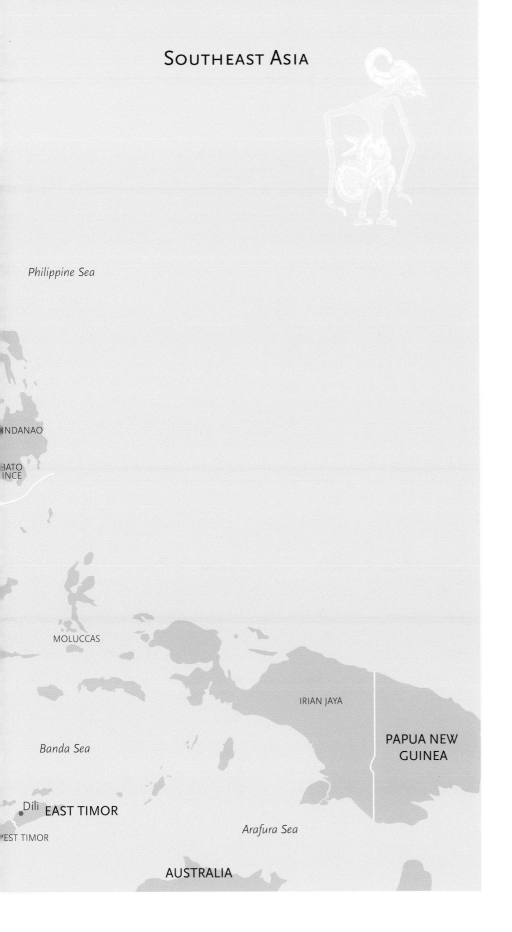

Philippine Sea

INDANAO

BATO
INCE

MOLUCCAS

IRIAN JAYA

Banda Sea

PAPUA NEW
GUINEA

Dili **EAST TIMOR**

Arafura Sea

EST TIMOR

AUSTRALIA

The Tai language is not only the principle language of Thailand. It is, in addition, spoken widely by the Shans of Burma, by the lowland population of Laos, and in the northern parts of Vietnam, Cambodia and Malaysia. Tai speakers are also to be found in the extreme south of China. The darkest area shows the distribution of Tai-speaking peoples.

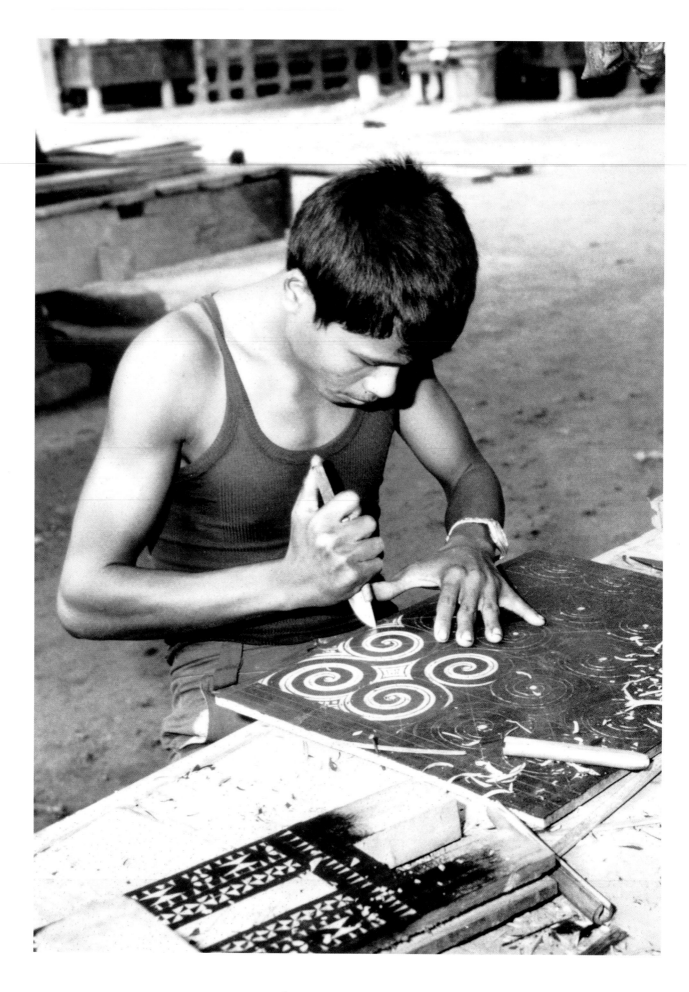

DIRECTOR'S FOREWORD

Arts of Southeast Asia has been published in association with the exhibition *Trade winds: arts of Southeast Asia* in the Powerhouse Museum's dedicated Asian Gallery. Both book and exhibition are based on the museum's Southeast Asian collection and bring another aspect of the museum's diverse and interesting collection into the public domain.

The Powerhouse Museum was founded in 1880, following the success of the Sydney International Exhibition of 1879. Among the first objects of Asian origin to be acquired by the museum was a group of Japanese ceramics from the display in the exhibition's Japan Court. These were followed by a collection of Indian pots and a group of Chinese musical instruments. Early acquisitions of objects from the Southeast Asian region include Burmese lacquer ware betel boxes and belt buckles of Malay silver.

Trade winds is the sixth exhibition to be held in the Asian Gallery which opened in 1997 to increase access to Asian decorative arts and design and foster a greater understanding of the richness and diversity of Asian cultures. The Southeast Asian region, which comprises ten independent states and East Timor, is a near neighbour of Australia and a great contributor to Australian cultural as well as economic and political life. Southeast Asia is at once a unified entity and a vastly varied region where external cultural influences have been traded and adopted into existing systems for millennia building up a rich and complex layering of social, religious and artistic practices — a kind of cultural palimpsest.

A large proportion of immigrants to Australia come from Southeast Asia, and just as previous waves of migration have changed Australia's sense of itself, their presence is shaping the way Australians think about their nation and the world, and the way the world sees Australia. *Arts of Southeast Asia* constitutes a timely contribution by the Powerhouse Museum to communicating the vibrancy of the arts of the Southeast Asian region as well as Australia's engagement with it.

I would like to thank Dr Milton Osborne for his elegantly concise essay on Southeast Asian history and his enthusiasm for this project. I also wish to acknowledge all Powerhouse staff and others who have contributed to this publication and the development of the exhibition. In particular, I would like to thank Christina Sumner, curator of decorative arts and design, for initiating and coordinating the project, and Melanie Eastburn, curator of Asian decorative arts and design, who has worked closely with her throughout.

Dr Kevin Fewster AM

Spiral motifs similar to those used on ancient Dong Son bronzes are still worked in various media throughout Southeast Asia. A Toraja craftsman carves spiral patterns in a panel for use in one of the elaborate and gaily painted Toraja houses in central Sulawesi in Indonesia.

Photograph by Hedda Morrison, 1978, Powerhouse Museum collection, gift of Alastair Morrison, 1992

An overview of Southeast Asian history
Milton Osborne

Surprising as it may seem, the widespread use of the term 'Southeast Asia' and the contemporary conventional acceptance of its being composed of ten independent states dates from the recent past.[1] Seventy years ago only a very limited number of Western scholars thought of and spoke about Southeast Asia. To the extent that there was any attempt to characterise the region in a general fashion, some writers used the term 'Further India'. This was a description coined to describe countries such as Burma (now officially Myanmar) and Cambodia, which had sustained Indian cultural influences in the distant past. Persons who used such a term were adopting a view that these countries were little more than India writ small. In thinking of Southeast Asia as a whole, it is necessary only to reflect on China's influence over Vietnam's cultural life to realise the inappropriate nature of the term Further India, and how little it applies to the eastern islands of the Indonesian archipelago, which historically had little if any contact with Indian cultural values. Equally, such a term gave no importance to the very deep influence of Spanish colonialism in forming the cultural character of the Philippines.

Political factors played a part in limiting the extent to which there was any widespread readiness to discuss the Southeast Asian region as a whole. Until World War II all but one of the countries that we now refer to as forming Southeast Asia were ruled by colonial powers. The exception was Thailand, whose able kings and officials adroitly avoided submitting to colonial rule. By the beginning of the 1900s, Britain ruled over Burma and the territories that make up modern Malaysia and Singapore, and controlled Brunei as a protectorate. France was the colonial power in the countries grouped as French Indochina—Cambodia, Laos and Vietnam—while the Dutch ruled in the territories of modern Indonesia, then known as the Netherlands East Indies. Completing this picture of colonial rule, the United States held power in the Philippines, having supplanted Spain in the aftermath of the Spanish-American War at the end of the 1800s, while Portugal had a minor presence in what has become East Timor.

Before World War II, rather than speak of the region as a whole, the general inclination, outside of a very limited number of specialist scholars in Europe, was to refer to countries by their colonial association. So people spoke of British Burma or the Dutch East Indies. Yet if this was the pattern of common speech, scholarly and political factors were at work that were to change this approach.

Unity in diversity

By the 1930s there was a steadily growing body of European scholarship that took account of the manner in which the early history of the countries of Southeast Asia involved shared cultural and political experiences. This was particularly so as attention was given to the countries that had experienced Indian influences: Burma, Cambodia, Laos and Thailand in mainland Southeast Asia, and important regions of modern Indonesia, especially Java and Sumatra. Historians and anthropologists recognised that there were similar characteristics in the rituals of the courts that had existed in mainland Southeast Asia before the onset of the colonial period in the 1800s. At the same time it became clear that Hindu

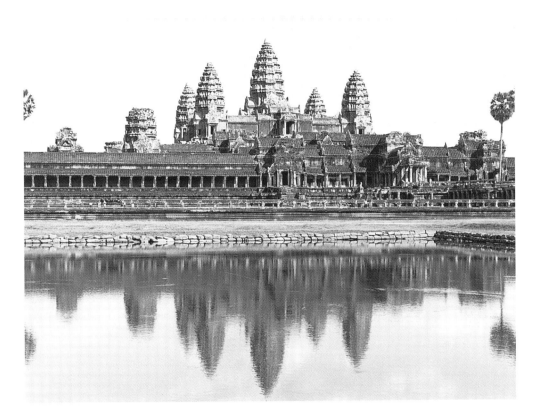

Angkor Wat is the grandest of all the temples in the Angkor complex in modern Cambodia and the largest religious building ever constructed. Built during the reign of Suryavarman II (1113–1150), it is believed to be both a temple dedicated to Vishnu and a funerary temple for the king.

Photograph by Oliver Howes, 1970

and Buddhist beliefs had played a major part in shaping the great temple remains found in both the mainland and maritime regions. And for all the evidence that had accumulated indicating the importance of influences from outside Southeast Asia, historians, particularly in France, began to assemble evidence that showed there had been a regional pattern of international relations existing from the earliest times. In short, it was recognised that Southeast Asia was a region that deserved attention in its own right.

Moreover, research began to reveal the strength of indigenous, as opposed to imported, cultural traditions and practices. For example, it is clear that wet rice cultivation, one of the most important agricultural practices found throughout Southeast Asia, is indigenous in origin. And where Indian or Chinese influence did play a part in the development of Southeast Asian art, or religion, or political theory, Burmese and Cambodians, Indonesians and Vietnamese adapted these foreign ideas to suit their own needs or values. Two examples make the point, one cultural, the other political.

There is no denying the profound influence of Indian religions and culture, including concepts of how to organise the state, and the manner in which they contributed to the rise to power of the Cambodian empire based at Angkor. Yet whatever the importance of these influences, the temples built by the Cambodians at Angkor are clearly different from those found in India. Starting from shared religious ideas and iconography, architecture and sculpture at Angkor is infused with its own separate, Cambodian genius.

Although Vietnam was deeply influenced by Chinese political theory, the officials of the two countries held quite opposite views on the preferred post to be occupied by a senior official. For the Chinese it was to be a senior mandarin in the provinces, for the Vietnamese the contrary was the case, with a senior post at the court being seen as the goal to which an official should aim.

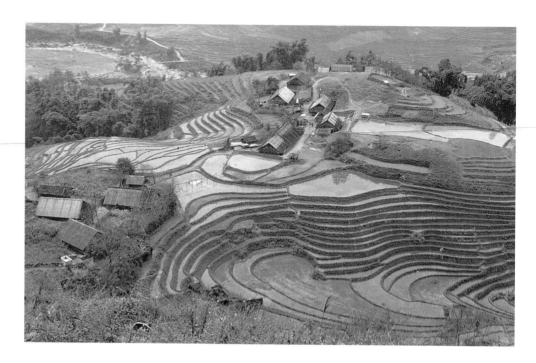

There was another factor that pointed to commonalities beyond the colonially imposed boundaries of the various Southeast Asian states: the widespread linguistic unities found throughout the region. Linguists noted that on the mainland the Tai language was spoken not just by the people of Thailand but also by peoples living in Laos, Burma, south-western China, northern Vietnam, and in small areas of both Cambodia and the northern states of modern Malaysia. Another important instance of linguistic unity is the broad spread of the Indonesian/Malay language. There are dialectical differences from region to region, but variants of this language are spoken throughout modern Brunei, Indonesia and Malaysia, and in the southern Philippines, as well as along the coastal regions of Cambodia and southern Vietnam, where there are long-established Indonesian/Malay speaking communities.

The possibility of thinking of the countries of Southeast Asia as a region with its own identity gained further currency as the result of strategic considerations during World War II and events following the end of that war. During the war the formation of an Allied Southeast Asia Command reflected the fact that the fight against the Japanese was taking place in a region that was neither India nor China. Then, after the war, the emergence of independence movements, in some cases revolutionary and in others seeking peaceful constitutional change, spurred an interest in the shared political problems of the region.

Yet just as the national motto of Indonesia is 'Unity in diversity', the fact of shared past historical experiences and contemporary political challenges should never obscure the extent to which is there is diversity as well as unity in Southeast Asia.[2] The region covers a vast area of the globe, stretching over more than 35 degrees of latitude and nearly 50 degrees of longitude. Its topography can vary dramatically, from the foothills of the Himalayas in northern Burma to the primary jungles of the island of Borneo. Its population has traditionally occupied lowland settlements along the seacoasts and rivers and lakes, but this tells us only part of the story. The demands of high-density human settlement in northern Vietnam in the Red River delta have led to a more intensive approach to agriculture than that followed by the much less concentrated Vietnamese population in the Mekong delta.

Even more striking are the differences between hill and valley and between those areas favoured by climate and those where rainfall is uncertain and infrequent. An imagined picture of Southeast Asia as a region of lush growth, rich soils and pervasive fecundity is only partly correct. It can be all these things, but it can also be an area where disadvantaged minority groups eke out a precarious living in upland regions using techniques of nomadic slash-and-burn agriculture that have serious environmental costs.

Southeast Asia's demographic character has changed dramatically over the recent past. Until the middle of the 1900s, the overwhelming majority of the population lived outside the region's urban centres. Today, urban centres have swelled to the point where in some cases over 40 per cent of a country's population live in cities (in the Philippines 45 per cent and in Malaysia 44 per cent). Even in Indonesia, by far the largest of all the countries of Southeast Asia, 30 per cent of the population is now urban based. Only in Cambodia and Laos do old patterns still apply, with some 80 per cent of the population still living in the rural areas. Demographic changes of these sorts alert us to the manner in which Southeast Asia's recent history has involved a major transformation from largely peasant-based societies to growing urbanised communities increasingly linked to a globalised world. Change, of course, has been a consistent theme throughout the region's recorded history. What is striking about Southeast Asia's recent past is the rapidity with which change has taken place.[3]

From protohistory to the period of great empires

Archeology provides insights into Southeast Asia's history before it is possible to consult written records. Through archeology researchers have established that as early as 500 BCE (before the Common Era) Southeast Asia was inhabited by peoples who produced a highly developed metal culture. There are examples of this culture, called the Dong Son culture from a type site in northern Vietnam, in both the mainland and maritime regions. Finds of decorated ceramics in Thailand date from even earlier periods, perhaps as early as 3000 BCE, and well before the first century CE (Common Era) there is evidence to show that the mainland region was part of a trading pattern that saw goods being received from the Indian subcontinent. By the beginning of the 1st century an east-west trading pattern existed between China and India that passed through Southeast Asia, and even reached the Mediterranean world. This trade involved the use of coastal entrepots. The best known and possibly most important of these was Oc Eo, located close to Vietnam's south-western border with Cambodia. Goods passed through Oc Eo either before or after being transported across the Kra Isthmus dividing the Andaman Sea and the Gulf of Thailand.

By the third century Chinese records start to supplement archeology and to dissipate the mists of protohistory. From this point on attention has focused on the rise to power of land-based kingdoms in Cambodia and Java and on a maritime polity linked to the Straits of Malacca. The Indonesian-Malay maritime power known as Srivijaya and the Angkorian empire with its centre in modern Cambodia have attracted great interest among scholars for they typify the two very different kinds of states that can be identified in the early or 'classical' period of Southeast Asian history.

Chinese records show that as early as the third century a state existed in the south of modern Cambodia, which the Chinese called 'Funan', and that Funan and its successor, which they called 'Chenla', were predecessor states to the Angkorian kingdom that emerged in the 9th century. This kingdom grew in power to become the dominant state in mainland Southeast Asia over the course of seven centuries. Angkor left behind a magnificent heritage

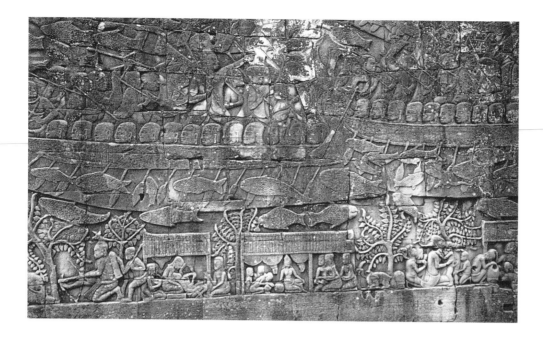

in terms of its temples and a body of records in the form of inscriptions carved in stone. Other important states rose to prominence in central Java and these have left the legacy of the temples at Prambanan and the great Buddhist stupa of Borobodur. In Burma another mainland empire emerged that constructed the great temple complex of Pagan. But the records from Angkor, and the intense study made of these records, have provided an unparalleled opportunity to understand the nature of land-based states in early Southeast Asian history.

At its zenith, Angkor was at the centre of an empire stretching into modern Thailand, Laos and Vietnam. Angkor was not indifferent to trade, but it did not depend on trade for its existence. Instead it evolved an agricultural economy that required the sophisticated management of water resources. In its heyday it was able to produce sufficient food to maintain an urban population of upwards of one million persons and to service the thousands of priests who presided over the rituals held in its many temples.

The power of its rulers depended both on the acceptance of the religious/moral authority of the king at Angkor by those who administered the empire's outer provinces and their knowledge that failure to accept that authority could result in the ruler marching against them. But once that authority was no longer accepted, as happened by the 1300s and 1400s, Angkor went into decline. The Siamese (Thais) who had once been Angkor's vassals turned against their overlord. Their attacks against Angkor brought a fundamental change in the balance of power in mainland Southeast Asia, with the Cambodian court finally abandoning the great temple complex towards the middle of the 1400s to move to the area of modern Phnom Penh.[4]

Angkor's identity was bound up in the great temples built by its rulers and which symbolised both their power and the protection accorded the state by the deities to whom the temples were dedicated. They remain a source of wonder to the present day.

In great contrast, the maritime state of Srivijaya has left only the barest of physical remains. Moreover, in further contrast to Angkor, the capital of Srivijaya moved several

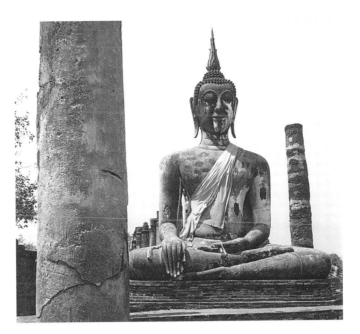

One of the Thai cities that rose to power as Angkor's authority declined was Sukhothai. Located in north-central Thailand, Sukhothai flourished in the 1300s when it testified its attachment to Theravada Buddhism through great monumental Buddha images such as that seen here.

Photograph by Milton Osborne, 1981

times in the region of the Malacca Straits, with a site close to modern Palembang in southern Sumatra as its most important location. It was from here, in concert with allies along the straits, that Srivijaya controlled the east–west trade between China and India. Importantly, Srivijaya's sailors developed skills that enabled them to sail from the Straits of Malacca to China and return without intermediate landfalls.[5] This capability spelt the end to the earlier trade pattern that had involved the passage of goods through entrepots such as Oc Eo. Backed by the Chinese emperor, the Srivijayan state flourished between the 7th and 13th centuries until the expansion of China's own seaborne trade into the southern seas undermined Srivijaya's raison d'être.

Brief mention must be made of Vietnam, in so many ways an 'outsider' in any discussion of Southeast Asia because of its adoption of Chinese rather than Indian cultural values. Until 939 CE Vietnam formed part of the Chinese state, but in that year it threw off Chinese overlordship. From that point on, with the exception of a short period of occupation by the Ming dynasty at the beginning of the 1400s, Vietnam was an expanding independent state with a population that steadily moved southwards along the coastal littoral towards the Mekong River delta.

Before the 'colonial era'

The fall of states such as Angkor and Srivijaya did not mean that Southeast Asia slipped into a period devoid of any dynamism. Quite the opposite is true. For instance, as the power of Cambodia declined, there emerged a series of Thai kingdoms that both inherited many of Angkor's political characteristics and developed their own distinctive artistic styles in architecture and sculpture. The new and powerful state of Mataram rose to prominence in central Java in the 1500s following the decline of the previously powerful Hindu–Buddhist kingdom of Majapahit, based in east Java. In both Java and Sumatra the arrival of Islam in the 1200s eventually led to this religion being the faith of the overwhelming majority of Indonesia's citizens.

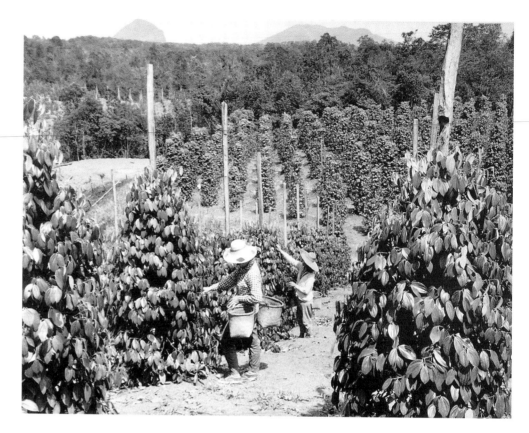

It is important to remember this sense of indigenous dynamism and the continuing importance of traditional values when discussing the arrival of Europeans in Southeast Asia, beginning with Portugal's capture of the great trading city of Malacca on the west coast of the Malaysian Peninsula in 1511 CE. The Portuguese and then the Dutch in Indonesia and the Spaniards in the Philippines were the precursors of the later colonial rulers, but until well into the 1700s the European newcomers had only a limited impact on the region outside their small coastal bases. For example, the extension of Dutch control over many of the territories that eventually became part of Indonesia largely took place in the 1800s. Dutch control of Bali was only finally achieved in the first decade of the 1900s. Indeed, until the 1800s most of the Southeast Asian region remained outside European colonial control.

The European advance and economic transformation

Trade, in particular the spice trade, brought the first Europeans to Southeast Asia. But it was only in the 1800s that a search for trading opportunities combined with imperial rivalry and a growing conviction among European powers that they had an inalienable right to rule over other nations. Colonies were seen as keys to national prosperity and this conviction led to a concerted effort to establish a presence in the region. One by one the countries that make up Southeast Asia today, with the exception of Thailand, fell under colonial rule. Remarkable though it may seem today, this was a period during which the prevailing European thought, as expressed by a Frenchman, was that 'nations without colonies are dead'.[6]

Viewed from the 21st century, the period of colonial rule in Southeast Asia appears strikingly exploitative. Alien overlords ruled subject peoples who had little if any say in the

ordering of their lives. The final response to this situation was the emergence of independence movements. Some, as in Indonesia and Vietnam, were movements that finally gained their goals through armed struggle. Others, such as those in the Philippines and Malaya (later Malaysia), achieved their goals through peaceful constitutional change.

Yet while the period of colonial rule involved great inequities, and in some cases brutal repression, the period leading up to the World War II had some positive characteristics, including the economic transformation of the region. This was when rubber plantations were established and mines were brought into production, when rice-growing areas expanded dramatically and when limited progress was made towards the introduction of modern Western education and the improvement of public health.

Clearly, the colonialists undertook these developments in their own interest, and some of the negative effects of colonialism remain to the present day. The problem of entrenched rural poverty in parts of Java, as one important example, dates from colonial times. Nevertheless, and particularly in relation to administration and infrastructure, the colonial powers laid a framework that was later important for the independent states of the region. And finally, if far from exhaustively, the colonial years were when the territorial boundaries of the countries in the region were firmly established. Despite a limited number of areas that remain in dispute, these boundaries have remained essentially unchanged to the present day.

The emergence of independent Southeast Asia

No single event has had more importance for the shaping of modern Southeast Asia than World War II. Put simply, the Japanese occupation of Southeast Asia showed the colonised peoples of the region that their colonial masters were not invincible. The eventual Allied defeat of the Japanese did not alter this fact. After the war, there could be no return to the apparent certainties of the colonial years, and within a period of ten years most of Southeast Asia was independent.

The governments that emerged in the countries of independent Southeast Asia varied greatly in political character. In North Vietnam (the Democratic Republic of Vietnam) a communist party held tight control over the divided state that had come into being in 1954. In Burma and Indonesia the military had an important role in government. Patron–client relationships were the order of the day in the fractious and free-wheeling politics of the Philippines, while in Cambodia and Laos the role of their respective royal families was of great importance.

Throughout the region independent governments faced great problems. Not least there was an expectation that independence would mean a better life for all and this expectation was seldom met. Tensions that had been obscured during the struggle for independence surfaced to plague governments, as was the case in Indonesia where some regions of the state unsuccessfully took up arms in the late 1950s as they questioned the right of Jakarta to dictate policy. Most dramatically, Vietnam became the site for a bitter conflict that was to last until 1975 and which took the lives of over three million Vietnamese. But if this was the most striking example of conflict there were many other instances of armed threat to the newly independent states. These ranged from the 'Confrontation' of Malaysia, mounted by Sukarno's Indonesia during the 1960s, to the continuing ethnically based resistance to the central government of Burma in Rangoon, and from the 1970–1975 civil war in Cambodia to Islamic separatist movements that still exist in the southern Philippines.

An end to Southeast Asia's post-colonial settlements

In their various ways the countries of contemporary Southeast Asia have abandoned or sharply modified the political settlements instituted at the time of independence. (Thailand can be included in this general observation despite its not having experienced colonial rule, for it too has moved away from the authoritarian governments of the 1950s and 1960s.) Indonesia's recent history makes this proposition very clear. Whatever was intended under the independence constitution, by the early 1960s President Sukarno had assumed the dominant role within the state, with the acquiescence of the powerful military. His fall from power was followed by the long authoritarian rule of President Suharto before the tumultuous events of recent times saw the emergence of a democratically elected parliament at odds with the country's president.

Developments in other countries have been no less dramatic and were, in the case of Cambodia, almost unimaginably tragic as the Pol Pot tyranny followed the bitter civil war fought between 1970 and 1975. In the Philippines, the excesses of the Marcos period were ended by a people's revolt, while in Malaysia inter-communal violence in 1969 led to a revision of the arrangements made at the time of independence in 1957 in order to give wide-ranging preference to ethnic Malays at the expense of other ethnic communities. Throughout Southeast Asia the financial crisis of the late 1990s has played a part in bringing into question past assumptions about the way in which governments, businesses and individuals should order their affairs.

Some of the challenges facing the countries of Southeast Asia are a continuation of old, unresolved questions about how governments should operate. Developments in Indonesia since the fall of Suharto illustrate this point as the issues of who holds power and how it should be exercised remain to be settled. Other challenges are new indeed, for example, the increasing degradation of the environment and the rapid growth of population, which places heavy demands on government services. Possibly most serious of all is the pandemic of HIV-AIDS that is already exacting a heavy toll in the region. While not yet approaching the level of crisis present in sub-Saharan Africa, this is a public health threat that is of rapidly growing proportions.

Modern Southeast Asia

Today, Southeast Asia faces manifold political problems. To cite just two examples, Indonesia is struggling to adjust to democracy after decades of authoritarian rule, while a military regime in Burma shows no inclination to yield power to its opponents who achieved a resounding success in an election held in 1990. The hope that ASEAN (the Association of Southeast Asian Nations) could act as a significant regional organisation has been compromised since the admission to its ranks of Burma and Cambodia, Laos and Vietnam whose governments or regimes are not in accord with the other members' shared commitment to liberal economic systems and broad acceptance of rights such as freedom of speech.

Yet the Southeast Asian region has a rich cultural present as well as a fascinatingly complex past. Where once scholarship on Southeast Asia was the preserve of outsiders, Southeast Asians themselves are now involved in unlocking the secrets of the past and revealing the inner meanings of their rich cultural heritage. Urbanisation and a fascination

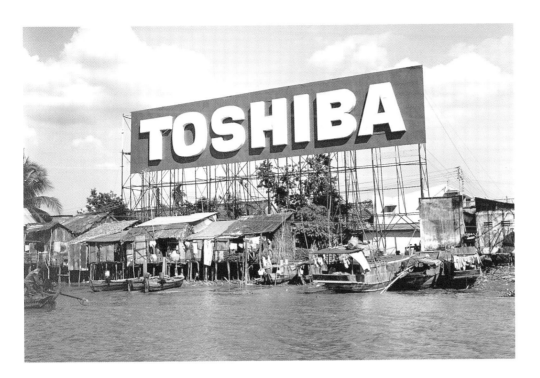

Southeast Asia is now firmly linked with the developed world with international brands for everything from computers to fast-food outlets found widely throughout the region. In this picture an advertisement for Toshiba looms over the Saigon River in Ho Chi Minh City (Saigon) in Vietnam in 1995.

Photograph by Malcolm McKernan

among the young with Western ways may be unstoppable developments, but much of Southeast Asia's traditional material culture continues to flourish as a vibrant link between the present and the past. For Australians in particular, given their geographic proximity, Southeast Asian history and culture offer a rich and fascinating insight into a region of the world that deserves to be better known.

Notes

1. By conventional definition, Southeast Asia is composed of the following ten states: Brunei, Burma (officially Myanmar), Cambodia, Indonesia, Laos, Malaysia, the Philippines, Singapore, Thailand and Vietnam. It seems probable that, once independent, East Timor will be added to this list.

2. The Indonesian motto in its original form is in itself a striking illustration of this fact. It appears on the Indonesian coat of arms as *Bhinneka Tunggal Ika*. The language of the motto is Javanese, not Bahasa Indonesia, underlining both the political importance of Java in the Indonesian state and the fact that this importance was taken by Indonesia's founders as outweighing the fact that Javanese is not the national language of Indonesia.

3. The increase in size of Bangkok's population is instructive in this regard. In 1954 Bangkok's population was 800 000. In 1999 it had risen to an estimated 10.5 million.

4. Older studies of Southeast Asian history cite the exact date of 1431 for this abandonment, but more recent research opts for a less certain date, some time after 1431.

5. Remarkably, knowledge of Srivijaya's existence and presumed locatiion was not gained until the early 1900s through the researches of the great French scholar George Coedes.

6. These are the words of Francis Garnier from a pamphlet he published in 1864. He was later famous as the second-in-command of the French Mekong River expedition of 1866–1868.

Tradition and synthesis:
the decorative arts of Southeast Asia

CHRISTINA SUMNER

When as Australians we look to the nations that make up present-day Southeast Asia, kaleidoscopic images flood the mind: terraced hillsides green with rice paddies, tropical heat, monsoon rains, saffron-robed monks in quiet temple courtyards, ancient ruins, the heavy scent of flowers and spice, noisy overcrowded cities, dusty villages, island-strewn oceans, misty mountains, and extremes of poverty and wealth. Within this vibrant landscape the men, women and children of Southeast Asia constitute an ethnic mix of great diversity and multiple cross-border continuities. Their tremendously varied material possessions reflect their different places of origin and a broad range of materials, technologies, pattern and ornament. These possessions are both functional and highly decorative and, in addition, frequently embody and communicate significant cultural meanings.

This essay focuses on the vast array of beautiful and useful objects made by the people of Southeast Asia and the historical, geographic and socio-cultural factors that shaped the making of these objects. Although objects of foreign origin such as Chinese ceramics and Indian textiles have been in common use in Southeast Asia, this brief survey is concerned with objects produced in Southeast Asia itself, within the mainland states of Burma, Thailand, Cambodia, Laos and Vietnam; peninsular Malaysia, Singapore and Brunei; and the island states of Indonesia, East Timor (whose statehood is pending) and the Philippines.

In terms of function, objects made for daily and special-occasion use in Southeast Asia are very similar to those familiar in Western cultures and elsewhere in the world. They include dress and dress accessories, coverings and hangings, cooking and eating utensils, all sorts of containers, tools and weapons, musical instruments, and the various accoutrements of performance, ritual and ceremony. Their form and ornament are however distinctively Southeast Asian and they also exhibit great regional variety. Rich diversity thus characterises the material culture of Southeast Asia as a whole. In articulating the distinctive cultural and aesthetic expression of individual groups of people, the material culture of the region also serves to identify such groups ethnically and regionally.

Regional factors

The population of Southeast Asia consists mainly of Mongoloid peoples descended from seafaring Chinese who migrated south across the oceans to the archipelagos and down the river valleys into mainland Southeast Asia over some 5000 years. There they encountered the existing Australoid and Negrito peoples, some of whom still survive in isolated pockets of Malaysia and the Philippines. A series of cultures emerged with their own distinct art styles. Most people speak a form of one of three main language groups: Tai (in Burma, Thailand, northern Malaysia, Laos and Vietnam), Indonesian/Malay (in Indonesia, Malaysia, the southern Philippines and south-coastal Thailand) and Vietnamese, which has a common ancestor with Khmer and Mon.

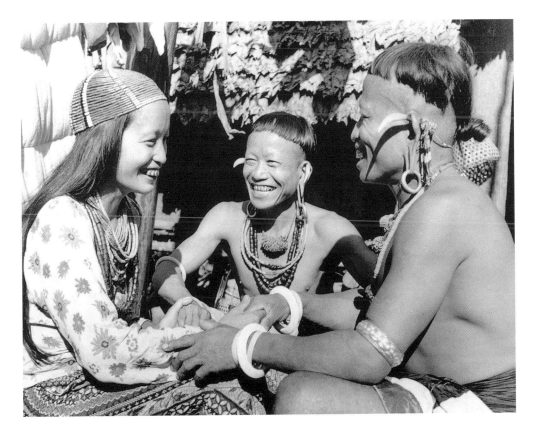

The people and cultures of Southeast Asia are remarkably diverse. A Kelabit woman in wedding finery poses for the camera with two Kelabit men in the highlands of Sarawak. The woman's cap is of semi-precious stones and the men wear metal earrings and leopards' eye teeth in their ears. All three wear many strings of highly valued beads.

Photograph by Hedda Morrison, 1953. Powerhouse Museum collection, gift of Alastair Morrison, 1992

Southeast Asian cultures can be characterised by those factors they have in common — the continuities that allow the region to be viewed as a discrete entity — and also by their myriad divergences and discontinuities. Geographically, the countries of Southeast Asia share monsoon weather patterns and the agricultural economy of wet rice cultivation. Topographical contrasts from place to place give rise to differences in available materials and social contrasts between, for example, the coastal (trading and fishing) and inland (farming) communities, and between lowlanders and highlanders. Social hierarchies divide the rulers from the ruled, while social structures tend to emphasise nuclear as opposed to extended families and the important role of women in their communities. Religion has had a significant impact — at times it has been a unifying force and at others divisive — and a great deal of iconography was derived from widespread Indian and Chinese influences. Today, the long-established regional social and artistic traditions of Southeast Asian nations, and their pre-colonial and colonial history, are significant unifying factors in defining national identities.

In traditional societies such as those of Southeast Asia, art was, like religion, an integral part of daily life for rich and poor alike. Artistic production was a communal expression of social coherence and cultural continuity rather than an outlet for individual creative expression and, until recently, the artists and artisans of Southeast Asia were anonymous. There was deep respect for ancient traditional forms, motifs tended to follow those of the past and radical works were rare.

The diverse cultures of Southeast Asia have nevertheless developed their own distinctive art styles whose symbolism preserves regional Neolithic and Bronze Age art forms and reflects animist and shamanic beliefs, as well as basic human concerns. The

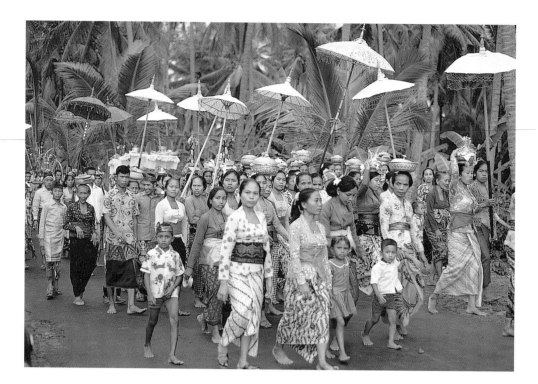

Tradition, ritual and ceremony play a significant part in the lives of Southeast Asian peoples. In Bali, ceremony marks important transitions from one stage of life to the next. Balinese funerary rites are complex and beautiful. Here men, women and children carry offerings as they walk to the village temple in a funeral procession.

Photograph by Beryl John, 1972

earliest motifs found on stone, bone and metal archaeological artifacts include heads symbolising prestige and fertility; horns, tusks and antlers representing wealth, aggression, protection and the male principle; and female breasts symbolising fertility and the female principle. Male and female, like life and death, are fundamental expressions of the duality that defines cosmic order in the Southeast Asian world view. Composite animal motifs include the *naga* serpent-dragon and the *makara* elephant-crocodile-fish and are symbolic of the links between humans and their broader cosmic and spiritual context.

Of lasting significance in forging a regional ornamental style in Southeast Asia was the sophisticated bronze-working Dong Son culture, which emerged about 500 BCE at a series of sites in northern Vietnam stretching from the Hanoi region southwards. The Dong Son people produced mainly burial goods and religious items, including monumental and magnificently ornamented drums. Many of these feature figurative scenes that include the rice culture, long boats, musical instruments, shamans and houses-on-stilts of a recognisably Southeast Asian world. Dong Son bronzes are also characteristically ornamented with spiral motifs, key patterns, diamonds and hooks; these motifs have survived to the present day and can be found in decorative arts throughout the region, especially jewellery and textiles.

Not surprisingly, bird motifs tend to symbolise the upper world, while boats and trees represent 'horizontal' transitions in the earthly plane and 'vertical' transitions from earthly plane to spirit realm respectively. These indigenous archaic images and symbols are representative of the universe and its principles of duality, help define social relations between human beings and their ancestors and mark transitions between the stages of life. Although they can be found throughout the region, the grammar of Southeast Asian ornament has also been enriched by centuries of cultural change due to local developments and the adoption of new ideas. Imported trade goods from India and China in particular had a major aesthetic impact on early ornamental styles.

The raw materials found in Southeast Asia include plant products (cotton, hemp, bark and pandanus, wood, bamboo and paper), animal products (silk, leather, horn and shell) and mineral resources (stone, glass, bronze, iron, gold, silver and precious gems). Respect for and adherence to traditional forms exerted a strong influence on the choice of materials and technology. Differences in design and shape, and pattern and motif characterise the material products of particular regions and ethnic groups and distinguish them from those of other peoples. These distinctions are determined by the interplay of demand, available materials and technology, inherited traditions and external influences. While some decorative textile technologies, such as ikat and supplementary weft, are strongly identified with Southeast Asia as a whole, regional specialisations such as lacquer ware in Burma, batik in Indonesia and ceramics in Vietnam also developed through a combination of internal and external factors.

External influences

Cultural influences from outside Southeast Asia, particularly from India and China, have been profoundly felt throughout the region, affecting the development of social structures as well as the form and ornamentation of material goods. The impact of Indian decorative styles is particularly evident in the architecture, sculpture and textiles of Southeast Asia. Indian political, philosophical and religious ideas were also widely disseminated, and absorbed and transformed into new structures that at the same time sustained indigenous forms. More recently, European colonial powers divided Southeast Asia (with the exception of Thailand) between them. Their colonial presence has not only impacted on art forms but has had long-term political and economic consequences for the region.

Since the earliest days of ocean-going sailing, Southeast Asian ships voyaged west to India or east to China (and back again) before the prevailing monsoon winds that blew south-west from May to September and north-east from October to May. Foreign vessels from India and China, and eventually from Europe, also sailed before the trade winds and anchored in Southeast Asian harbours. These traders exchanged the natural resources of Southeast Asia — timber, spices, gold, precious gems, wild birds and animals — for manufactured foreign goods such as textiles, ceramics and currency.

Indian traders and travellers brought with them the Hindu and Buddhist religions, literature, philosophy, and ideas about law and kingship. These held that kings ruled by heredity and divine authority, and placed emphasis on the king's control of wealth and trade. Rulers were provided with parasols, canopies and elephants as symbols of kingship and elaborate ceremonies were held for their appropriate recognition. These customs appealed to the local elites and were enthusiastically grafted onto existing social systems. Although social hierarchies had existed in Southeast Asia before the arrival of Indian traders, authority was based on personal experience and prowess, and the chieftain's observed control of agricultural and fertility cycles. Chinese writings of the third century BCE tell how the kingdom of Funan in southern Vietnam was founded when an Indian Brahmin married the daughter of the local serpent-dragon deity. The symbolism of this foundation myth is striking, telling as it does how civilisation in Southeast Asia was born from the marriage of indigenous resources and imported social institutions.

Hinduism and Buddhism were established in Southeast Asia by the seventh century CE. Their presence is marked by monuments such as Hindu Prambanan and Buddhist Borobodur in central Java, Pagan in Burma, Angkor in Cambodia and the Cham sites in central Vietnam.

The form and ornament of each of these monuments were also strongly shaped by pre-existing indigenous aesthetics. Hinduism is still the principal religion in Bali while the Hindu epic poems the *Ramayana* and *Mahabharata*, brought from India in the eighth century, have inspired art, drama and morality in many Southeast Asian states. Buddhism remains the dominant religion of Burma, Thailand, Cambodia and Laos, where its imagery and ideals have had a great impact on material culture. Largely through the efforts of Indian and Arab Muslim traders and returned indigenous Muslim pilgrims from Mecca, the majority of people in Malaysia and Indonesia were converted to Islam which, with its love of ornament and ceremony, has had a profound influence on Malay and Indonesian decorative arts. With the establishment in the 1500s of European trading companies and colonies in the area, and the advent of Portuguese and Spanish colonists, significant pockets within the Indonesian archipelago and numbers of Filipinos converted to Christianity, which has also had an impact on the decorative arts.

China, which borders on the northern regions of Burma, Laos and Vietnam, has long exerted a strong cultural influence on Southeast Asia, particularly in Vietnam where Indian influence was more limited. Among the coveted trade goods from China were ceramics and, by the early 1300s, strong demand for these prompted the production in Vietnam and Thailand of locally made, and visually and technologically similar, wares. In Borneo, designs of the Zhou dynasty (1122–221 BCE) are still apparent in the spirals and dragons of Dayak art, and large Chinese dragon jars have been found in remote upland villages where they were passed down through generations as highly valued heirlooms. During the Angkorian period, Chinese expansion westward was kept in check but, by the 1500s, the Indianised states of Cambodia, Laos and Thailand were overtaken by Chinese influence. The name 'Indochina' reflects the meeting place of these two great civilisations. The descendants of the Chinese who settled along the Malacca Straits in western Malaysia some 600 years ago are called Straits or Peranakan Chinese, and produce a distinctive range of silverware, beadwork and embroidery. By the 1900s, the impact of Chinese culture could be observed throughout Southeast Asia as Chinese communities further established themselves in the region. For example, batiks with a clearly articulated Chinese aesthetic were produced by the Peranakan Chinese in north-coast Javanese workshops to satisfy local tastes.

Textiles and dress

Throughout mainland, insular and peninsular Southeast Asia, women with consummate skills have for centuries produced a tremendous range of beautiful textiles using a variety of materials and techniques. Equally fine and detailed work was produced in princely courts and remote villages (although village work could also be quite rough and ready) and these splendid textiles are arguably the primary art form of the region as a whole. Textiles perform everyday functions such as covering and protecting the body, wrapping belongings and defining domestic and ritual space. In addition, their form and ornament may be expressions of group membership, marriageability, individual wealth or magical power. Many textiles and items of clothing were specific to particular circumstances, and often played a central spiritual and symbolic role in the ritual and ceremony of domestic, community, state and religious domains. More recently, textile production has become an important source of income for a number of communities.

The use of leaves, plant fibres and bark to make textiles and body coverings dates back to very ancient times and survived until recently in some isolated and widely separated parts

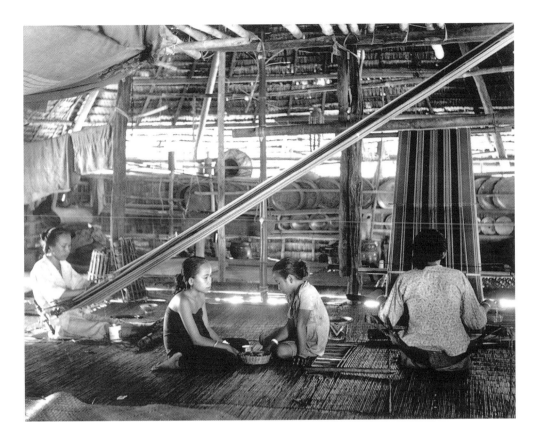

Two Bajau women weave on body-tensioned looms in their house at Kota Belud in Sabah, Malaysia. The warp is tensioned by the weight of the woman's body as she leans back against the back strap. The other end of the warp is tied to the roof timbers.

Photograph by Hedda Morrison, 1950. Powerhouse Museum collection, gift of Alastair Morrison, 1992

of Southeast Asia such as the islands west of Sumatra, Luzon in the northern Philippines, central Sulawesi and Borneo. The similarly ancient technology of twisting and plaiting leaves and plant fibres together to make mats, hats and a wide variety of baskets endures to the present day. Cotton was spun and used during the prehistoric era in mainland Southeast Asia, but was introduced in the islands only about 2000 years ago. Hemp from the cannabis plant, *abaca* from the wild banana plant, a wild grass called *doyo* from Borneo, and pineapple or *piña* are also used for weaving. The principal dyestuffs were indigo for blues and blacks and, in the islands, a selection of roots, barks and wood shavings that included *mengkudu* (*Morinda citrifolia*), sappanwood (*Caesalpina sappan*) and *soga* from the bark of the soga tree for reds and browns; in mainland Southeast Asia, lac from insects was the most common source of red.

While exhibiting certain general similarities, the textiles of one cultural group are characteristically distinct from those of another and help define group identity. Textiles from neighbouring and widely separated groups of people may exhibit shared features or they may be quite different. Similar or related motifs are found in textiles throughout Southeast Asia. These include the geometric motifs, birds, animals and composite mythical creatures of local genesis as well as ornamentation inspired by foreign influences. Indian ornament, Hindu and Buddhist iconography, Chinese symbolism, and Islamic and European art can all be identified. Perhaps the genius of Southeast Asian textile artists lies in the synthesis of these myriad influences, the ability to sustain traditional forms while at the same time adapting to change and responding to new ideas and new materials.

Simple body-tensioned looms with a continuous circulating warp were once used throughout the region. These looms present certain constraints, notably limiting the length and width of the cloth, which result in similarities of cloth form and garment structure. Design

Bejewelled classical
court costumes worn
by a troupe of *khon*
performers in Thailand
in the late 19th century.
The *khon*, or masked
drama, is a classical
Thai theatrical form.
Its storyline, the
Ramakian, tells of the
triumph of good over
evil and was inspired
by India's epic tale, the
Ramayana.

Photograph by Robert Lenz, 1890,
reproduced from *Arts and crafts
of Thailand*, Thames & Hudson,
London, 1994

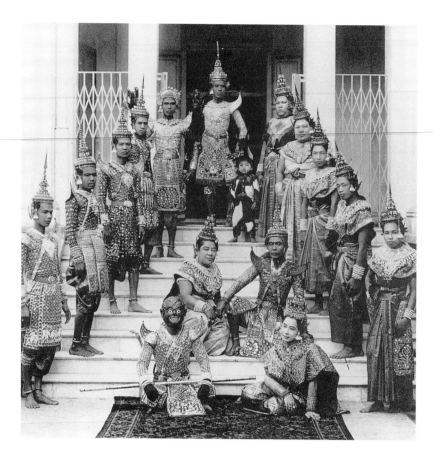

opportunities are nevertheless available through warp and weft stripes, warp ikat designs, and the addition of numerous heddle shafts for complex supplementary weft patterning. Body-tensioned looms with a long warp fixed to a post, and frame looms, on which wider cloth can be woven, were also used.

Ikat, supplementary weft, batik and embroidery are the most widely known methods of decoration in Southeast Asian textiles. In ikat, the warp or weft or both warp and weft threads are tie-dyed with the desired pattern before weaving begins. Supplementary weft patterning occurs during the weaving process itself with the insertion of coloured pattern threads. Batik, like ikat, is a resist dye process but patterning occurs after the cloth has been made. Warp-ikat textiles are mostly cotton and are found throughout Indonesia, and in limited quantities in Thailand, Laos and Vietnam; the T'boli people of the Philippines weave warp ikats from *abaca*. Weft-ikat textiles however are usually of silk and are found in mainland Southeast Asia as well as Malaysia, Sumatra and Bali in Indonesia and Mindanao in the Philippines. The rare and beautiful double-ikat cloths known as *geringsing*, in which both warp and weft are tied and dyed, are technologically very challenging and are woven in east Bali.

Indonesian warp ikats, typically dyed with dark blues and reds, are some of the best known of all Southeast Asian textiles. They are produced by women on body-tensioned looms in a range of rectangular shapes and sizes to suit a number of purposes, particularly clothing and ritual. Despite utilising the same ikat technique, the motifs and overall design in cloths from different part of Indonesia show astonishing variety. For example, in Sumbanese *hinggi*, which are used for ceremonial wear and ritual gift giving, animals, fish, ancestor figures, skull trees and other figurative motifs are typically arranged in broad horizontal bands.

Large ceremonial *pua* (blankets), made by the Iban people of Sarawak, are predominantly red and often feature a striking overall field design filled with spirit beings and Dong Son-style hooks and diamonds within narrow side borders. The Toraja people of central Sulawesi produce huge ceremonial hangings for display during their funerary rites; the central field in these is proportionately much smaller and surrounded by broad borders.

The majority of the mainland populations of Thailand and Laos, together with minority groups in Burma and Vietnam, consists of people who speak related Tai languages. The basic forms of textiles made by Tai speakers include clothing, domestic and ritual textiles, and small squares of cloth, which are exchanged as ritual gifts. All have narrow weft dimensions, which suggests the Tai originally used a body-tensioned loom rather than the wider treadle frame loom typically in use today. The *phaa sin* (skirts) worn by Thai and Laotian women are made from three bands of narrow cloth and thus reflect these earlier forms. Warp patterning traditions such as warp stripes, complementary warps and warp ikat predate weft patterning techniques such as supplementary weft and weft ikat. Although both warp and weft patterning techniques are found in Tai textiles, they are overwhelmingly patterned with supplementary weft on a plain or twill ground.

The shift to weft patterning occurred in Southeast Asia as a result of Indian influences and with the introduction of silk to the region. Textiles became important as markers of rank and status and as indicators of wealth. The finest and most elaborately decorated were of silk and gold. Cloths that combine silk weft ikat with supplementary weft patterning are mainly associated with the courts of Terengganu and Sumatra. These were never imbued with the same sacred and magical meanings as warp patterned cotton cloths, but were valued as expensive and beautiful commodities essentially associated with privilege and courtly life. Some of the most skilled weavers were employed at Terengganu, where the costly weft ikat *kain limar* was made. Cloth decorated with silver and gold supplementary weft patterning is called *songket* and is mostly produced in Malaysia, where it has become the accepted wear for bridal couples. In Malaysia, as well as in Java and Bali, floral patterns in gold leaf are sometimes applied to the surface of cloth.

Batik is intimately associated with Indonesia, particularly with Java, and has since independence assumed the status of national dress. Batik is worked by marking the design on the cloth with hot wax, using either the *canting*, a bamboo tool with a spouted copper reservoir of different diameters, or the *cap*, which is much like a printing block. The waxed areas resist colouring when the cloth is dyed and, through repeated waxings and dyeings, complex multicoloured patterns can be created. The technique is thought to have been introduced comparatively recently from India, as a close relationship exists between batik and Indian mordant-dyed cloths. Simple batik using a mud-paste (rather than wax) resist occurs however in some of the outer islands of Indonesia and may represent an earlier local tradition.

Central Javanese batik patterns, with their lush plant forms, curling tendrils and birds, are traditionally dyed in indigo blues and *soga* browns; batiks from the central-north coast of Java (Pekalongen, Lasem and Cirebon) display strong Chinese and European influences and a wider colour palette. Batiks have also been produced in Malaysia from the 1920s using the *cap*, with designs derived from those of north-coast Java. In the 1960s a new breakaway Malaysian style was developed in which colours were handpainted on silk within wax-drawn contours. Today, studios in Yogyakarta are producing exquisite silk batiks, with contemporary designs inspired by and incorporating traditional patterns and motifs, for local and foreign markets.

As well as the patterning of cloth through weaving techniques and the application of paints and dyes, embroidery also embellishes some Southeast Asian textiles and dress. Traditional gold-thread embroidery, which probably derives from Indian, Chinese and Persian influence, was used for men's and women's court costumes and interior furnishings in the Malay world. The Minangkabau of west Sumatra have produced some of the finest examples of this type of embroidery. The extraordinarily fine work of the Hmong women of northern Vietnam, Laos and Thailand is ranked among the great embroidery traditions of the world. The Hmong have been listed among the ethnic minorities of China, where they are known as the Miao, for at least four millennia. When they migrated into Southeast Asia between 200 and 400 years ago, the women took with them their costume-making techniques such as hemp weaving, folded and banded appliqué, cross-stitch and batik. From 1976, many Laotian Hmong refugees have lived in refugee camps in Thailand, having fled their villages and crossed the Mekong River to escape government reprisals against them following the military withdrawal of their US allies from Laos. The Laotian Hmong keep their culture and history alive through making embroidered 'story cloths'.

Shells, beads and other trinkets have added extra richness and interest to textiles and clothing for thousands of years. The earliest beads, made from shells, seeds and stone, were originally imported into Southeast Asia from India and China but they have been made locally since the first century BCE. Beads are often highly valued as heirlooms and for ceremonial use, and are traded widely. Traditionally made by men, their use to ornament textiles made by women links the male and female domains. Outstanding examples of Southeast Asian beadwork include the heavily ornamented Dayak jackets and skirts of Kalimantan, with imagery that portrays information about Dayak social structures and world view. In Mindanao in the Philippines, Kulaman women used white seed beads to ornament their blue cotton blouses. Traditionally, Straits-born Chinese *nonyas* (women) learned beadwork as children, and beaded slippers, purses, bags and belts for their trousseau.

Jewellery and metalwork

For a very long time, magnificent jewellery has been produced in Southeast Asia, from the isolated outer islands of Indonesia and the Philippines to the mountain villages of Laos and Thailand and the court societies of Java and Sumatra. Much of it has been made of gold. At least 2000 years ago Java was described by Indian writers as the island of gold. Gold was also mined in Sumatra, southern Borneo, the Malay peninsula and the Philippines. Elaborate gold jewellery, often laden with precious gems, was worn at court in extravagant displays of extreme wealth and privilege. Silver deposits were less common but silver was mined in Burma, Laos and Thailand; silver was also imported in the form of ingots or coins. Some minority groups on the periphery of court societies made gold and silver jewellery from coins received by them in exchange for spices, sandalwood and horses.

Southeast Asian jewellery includes some spectacular pieces for both men and women. The forms and motifs often reflect Indian, Islamic or Chinese imagery, but typically these decorative influences have been absorbed and given a specifically Southeast Asian slant. In addition to serving as personal adornment, particularly apparent on the day of a young girl's wedding, the jewellery of Southeast Asia is rich with symbolism and is an effective medium for displays of wealth and status. When textiles were given in ritual exchange, jewellery was often the counter gift. One example, among all the richly diverse regional jewellery traditions

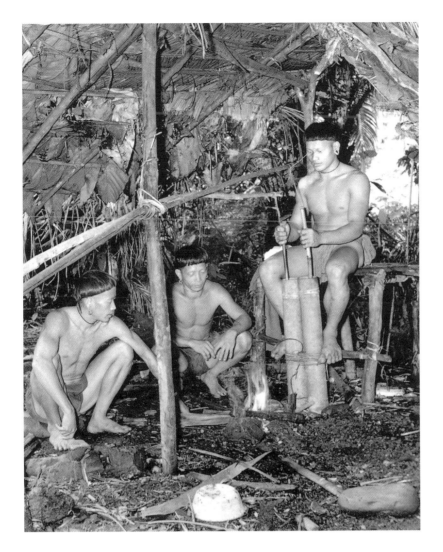

A group of Penan metal smiths work hot metal to make a sword or *parang*. They are using traditional technology of great antiquity in their village in Ulu Baram in Sarawak, Malaysia, in the 1960s.

Photograph by Hedda Morrison, 1960s. Powerhouse Museum collection, gift of Alastair Morrison, 1992

of Indonesia, is the golden buffalo horn-shaped *lamba* of Sumba, worn by men on the forehead or breast during important ceremonies. Silver jewellery of great complexity, and often considerable weight, was made and worn by minority groups such as the Karen, Hmong and Akha of Burma, Thailand, Cambodia, Laos and Vietnam. Like their beautiful embroidery, these jewellery traditions came with the people across the mountains from southern China.

Metalworking is a very ancient skill practised in both mountain village and urban workshop. The basic technology is straightforward, relying on the capacity to produce fire and the malleability of hot metal. Bronze tools were cast as early as 2000 BCE in northern Vietnam and bronze jewellery was made at Ban Chiang in Thailand by 1000 BCE. By 500 BCE, the Dong Son people were producing their elaborately decorated drums and trading bronze artefacts west to Thailand, south to Indonesia (where similar goods were produced locally) and east to the Philippines and the Pacific.

Metal, predominantly iron or steel, was widely used for the manufacture of domestic blades and weaponry, which were often highly ornamented and of great elegance. Sharp blades called *parang* were produced by traditional headhunters in Sarawak and the curving *barong* was a product of the Philippines. In Malaysia and Indonesia, the distinctive elongated dagger called the *kris* has been made for at least 600 years. Once associated only with the rich and powerful, and imbued with potent symbolic and magical powers, the *kris* is still

an object that merits great respect. The blade of the *kris* is typically but not exclusively sinuous and is always made of steel, with a hilt and sheath usually of wood or ivory and fittings of gold, silver, brass or copper.

A range of techniques are used to shape and ornament metal objects. Some objects are formed through casting, in which molten metal is poured directly into a mould, others by lost wax (*cire perdue*) casting, in which a wax form is made and encased, the wax burned out and molten metal poured into the casing to fill the area once occupied by wax. Brass casting probably came from Thailand and was used to make kettles, cooking pots, trays, vases, candlesticks and incense burners. Brass was also used to make the gongs for gamelan orchestras.

Copper, bronze, silver and gold are all relatively soft metals and can be shaped through alternate heating, cooling and hammering. In repoussé decoration the design stands out from the surface in relief; those areas to be raised are worked into shape from the back or front while defining the raised areas is done with a tracing tool and surface texture is added by chasing. Repoussé has been used in Thailand, Cambodia, Malaysia and Indonesia to ornament bowls and boxes, betel sets and large oval *pinding* (or belt buckles). Other forms of decoration include filigree work, which is found in Burma, Thailand, Malaysia, Indonesia and the Philippines, and *niello*, which was used in Malaysia. Filigree involves twisting and braiding fine silver or gold wire into different forms and is used to make elaborate jewellery and belts, or for adding ornament to the hilt of a *kris*. Malay silversmiths patterned items such as sword hilts, bowls and belt buckles with *niello*, in which black enamel is applied to the recessed areas of an embossed piece and polished smooth.

Ceramics

Pottery traditions also have an ancient, if somewhat chequered, history in Southeast Asia. The technology for making early open-fired earthenware was domestically based and pots were sometimes beautifully decorated with incised or painted geometric patterns. The major site for painted earthenware ceramics is Ban Chiang, in north-east Thailand, which flourished for some 4000 years until about 600 CE. Pots made by the Mon people in Burma between 400 and 900 show the influence of Indian stone and metal forms, in keeping with the general adoption of Indian cultural forms in the region. In Malaysia, terracotta pots were traditionally hand-built by women who shaped them with a wooden paddle or beater. Decoration typically consisted of rhythmic patterns either incised into the damp clay or impressed using wooden stamps carved with geometric or stylised plant motifs. Pots like these are still made without the aid of a wheel in a number of villages throughout Southeast Asia.

Kiln-fired glazed ceramics on the other hand demand a variety of specialised technical skills. In Southeast Asia, their production was a later, urban phenomenon that developed at different times in different places and was greatly influenced by Chinese technology and artistry. The best known glazed ceramics from Southeast Asia are those made in the kilns of Vietnam from the first century CE and in Thailand from around the twelfth century. The Vietnamese and Thai potters learned to high-fire stoneware from the Chinese example. They also drew artistic inspiration from Chinese forms and decoration, and combined them with their own traditions; the decorative influence of Indian sculptural forms and floral motifs is also identifiable. It is not yet clear however to what degree ceramic technology was imported or locally developed. While the trade ceramics of

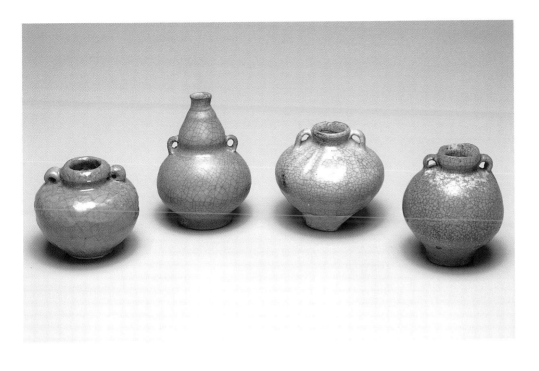

Thailand and Vietnam are relatively well documented through archeological findings, those of Cambodia, Burma and Laos are not so well known.

Glazed ceramics were made in Cambodia from the 1100s. The Khmer potters at Angkor produced distinctive vessels for their own use, often inspired by Indian forms and with a limited range of glazes disseminated from China. These included architectural and utilitarian wares and imaginative animal-shaped items for religious purposes. The Khmers however apparently preferred Chinese trade ceramics for general household use and, by the 1200s, their glazed ceramics industry was in decline.

In the early 1200s, the kingdom of Sukothai came to power in north-central Thailand. Its two major cities, Sukothai and the smaller Sawankhalok (present day Si Satchanalai) were both important centres of glazed ceramic production whose high-fired stoneware included vessels with underglaze iron-black decoration, rather than the cobalt blue preferred by Chinese and Vietnamese potters. Green-glazed celadon wares from Sawankhalok also reflect the direct influence of Chinese technology, which appears to have travelled westward to north and north-central Thailand and Vietnam in the 1300s. From the 1300s onwards, both Thai and Vietnamese ceramics were heavily involved in long-distance trade, much of it to Indonesia and the Philippines.

Although early Vietnamese wares owe much to Chinese style and technology, pots produced in Vietnam became progressively more Vietnamese in character from the 1200s and 1300s. Vietnamese ceramics are made from local clays and are technically very fine. Major kiln sites in the Red River delta in northern Vietnam were located near foreign trade routes, and northern Vietnamese ceramics were exported in large numbers from the 1300s to the 1500s. The best known comprise a wide range of stoneware bowls, bottles, cups, jars and *kendi* (spouted vessels) with a range of underglaze cobalt-blue designs that blend scenes from Chinese painting and Vietnamese calligraphic flower motifs. Large underglaze blue plates, often with floral decoration, were made for export to the rising Islamic courts of the Malay and Javanese world during the 1300s and 1400s.

Objects made from wood and canes

Southeast Asia is rich in timber resources such as teak, ebony and sandalwood; in Malaysia alone there are some 3000 varieties of timber. These resources have however been seriously depleted through the slash-and-burn agricultural practices of recently relocated peoples and large-scale commercial logging.

Wood carving with stone axes and adzes was practised at least as early as Neolithic times and buildings large and small were constructed of wood throughout the region. These were often elaborately decorated in the local style. In central Sulawesi, for example, Toraja houses have walls of carved and painted panelling while the lovely *wats* (Buddhist temples) of Thailand, Laos and Cambodia are lavishly embellished with gilded wooden ornament. In village contexts, woodworkers produced utensils for daily use and warriors carried wooden spears and shields carved with magical protective motifs. Carved ancestor figures were placed in small wooden spirit houses, sometimes with carvings of the Hindu gods, Buddha and the bodhisattvas alongside them on the altar. Fantastic masks (*topeng*) were made for use in Balinese dance drama, and beautifully grained wood was carefully selected for the handles, hilts and sheaths of *kris*. Today, ornately carved and inlaid furniture is produced in Thailand, Vietnam, Java and the Philippines for local use and for export.

Bamboo, rattan (*rotan* in Malay) and pandanus provide the raw materials for thatched roofs, woven walls and matting, furniture, musical instruments and baskets throughout Southeast Asia. Flexible and hollow bamboo, which grows extraordinarily quickly, is more a giant grass than a tree. Rattan, a member of the palm family, is a pliable and durable rainforest climber used in Borneo to make mats with spectacular patterns that often incorporate the same hooks and spirals as locally made warp-ikat textiles. Pandanus or screw-pine grows in sandy coastal areas; the shorter and finer leaves of pandanus are used to make a wide range of fine-quality domestic goods.

In addition to bamboo, rattan and pandanus, various other leaves and grasses are plaited, coiled and twined into a wide range of basketry goods. These are often elaborately patterned, either by using differently coloured fibre strands or through the addition of beads and shells. Plant materials were harvested from the immediate environment and traditionally coloured in golds and browns with vegetable dyes; more recently, brightly coloured baskets have been produced using commercial dyes. Basket making, which is done by both men and women in Southeast Asia, is one of the oldest of crafts and basketry forms have changed little over time. Baskets tend to have short lives, thanks to wear and tear and the perishable nature of the materials.

Finely woven or plaited bamboo provides a lightweight basketry base for the beautiful lacquer ware of Burma and Thailand. The basket is covered with a black pitch-like material that, when dry, is smoothed and coated several times with lacquer. Sometimes the image or pattern is incised directly into the lacquer base and the incised areas filled with colour; alternatively, the surface is painted with successive layers of colour and then scratched through to reveal the desired colour beneath. Designs or gold leaf may also be applied directly onto the lacquer surface.

Lacquer work is particularly associated with Burma, where it has long been a major artistic tradition. Lacquer wares are used for a wide range of Burmese household and ceremonial objects such as storage containers, offering vessels, betel boxes, screens and musical instruments. The technology for lacquer work originated in China although decorative

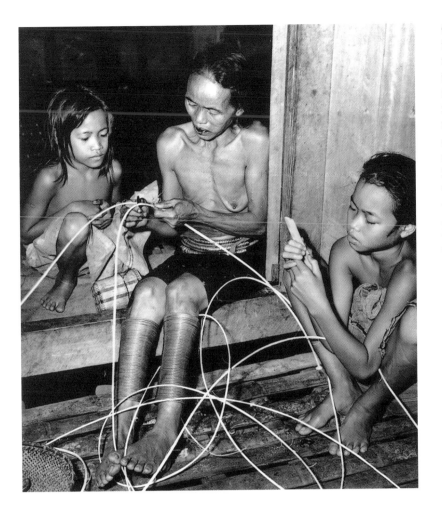

techniques such as the *yun* engraving practised in Pagan were introduced much later from Thailand. Pagan has been a major production centre since at least the 1200s. Ornamental lacquer boxes were also made in Sumatra in the late 1800s and early 1900s.

Musical instruments and the wayang world

The remains of early Southeast Asian musical instruments have been found in archaeological excavations, and images of instruments can be seen in wall paintings and reliefs such as those at ninth-century Borobodur and twelfth-century Angkor Wat. These pictorial records show a strong continuity between instruments of great antiquity and those in use today. Music was traditionally understood to have connections with the supernatural. As a result, musical instruments were made with suitable attendant ritual and were accorded due reverence. They are usually also highly decorative.

The principal materials used in making musical instruments are wood and metal. Sets of tuned wood or bamboo slats may be grouped together for striking. They are supported on beautifully ornamented bases to form instruments such as the *ranak ek* of Thailand and the Burmese *pattala*, which are similar in principle to the Western xylophone. In Java and Bali, bamboo tubes are used as flutes or strung together in a frame to form a kind of rattle called an *anklung*. The majority of Southeast Asian flutes, generically known as *suling* in Indonesia, Malaysia and the Philippines, are end-blown. Nose flutes are found in the Philippines and north-west Borneo. Metal percussion instruments such as gongs and cymbals are perhaps

the most distinctive musical instruments of the region as a whole, dating back to the bronze drums of the Dong Son people; similar drums are still found in mainland Southeast Asia. Gongs, which were probably introduced from China and come in a range of shapes and sizes, are played both horizontally and vertically, and are essential to music making throughout the region. Mostly, Southeast Asian instruments are played in ensembles, such as the gamelan orchestras of Java and Bali.

Another popular performance medium in Southeast Asia is the *wayang* puppetry tradition, which probably dates back to animist days in Java. *Wayang* means drama or play. The earliest *wayang* may have come from India; characters such as Rama, Hanuman, Arjuna and Bima from the *Ramayana* and *Mahabharata* tales were blended with local ancestor figures and became firm favourites. The puppets for *wayang* performances take different forms: three dimensional *wayang golek*, flat wooden *wayang klitik* carved in shallow relief and *wayang kulit*, the flat puppets of pierced leather (*kulit*). In *wayang topeng*, human beings wear masks to perform the familiar stories.

Wayang kulit, or shadow play, is the best known form of *wayang* and is found from Thailand to Malaysia to Indonesia. The puppets are made from buffalo parchment, cut and pierced to form individually stylised characters that are easily recognisable when projected in lace-like silhouette upon a screen. They are also painted in bright colours representative of the particular character, additionally embellished with gold paint and mounted on a horn handle for manipulation. In the 1900s, the techniques employed in making buffalo parchment shadow puppets were adapted to produce objects such as fans and notebook covers for the expanding tourist market.

The legacy

The traditional decorative arts and crafts of Southeast Asia are of early origin and reflect the exceptional diversity of the many peoples, communities and nations of the region. Blended with archaic indigenous forms and motifs were the ornamental styles, ideologies and technologies brought by pilgrims, traders and adventurers from India, China, Arabia and Europe. The resulting fusion of styles, in which these separate elements are distinguishable, comprises a uniquely Southeast Asian synthesis and an immeasurably precious inheritance for the people of Southeast Asia today.

With the progressive demise of traditional lifestyles and the mounting time pressures in contemporary monetary economies, many of Southeast Asia's traditional crafts are no longer made and the singular skills of Southeast Asian artists and artisans are no longer practised. However, the people of Southeast Asia are increasingly finding a reinforced sense of identity in their pre-colonial past and its treasures, and many artists and artisans have returned to traditional designs and techniques for inspiration. In addition, the ever-hungry tourist and interior design markets support the continued production of a phenomenal range of contemporary baskets, furniture, jewellery and textiles in the traditional idiom.

The proximity of Australia to Southeast Asia has brought sustained contact with the region since at least the 1500s when Makassarese sailors first beached their trepang fishing boats on the northern coast of Australia. Today, recognising its geographic position within the Asia-Pacific region, Australia seeks to promote cultural and economic links with neighbouring Southeast Asia. The publication of this book of the Powerhouse Museum's collection of beautiful and useful objects from Southeast Asia will, we hope, help to foster a deeper understanding of the lives and cultures of the people who made them.

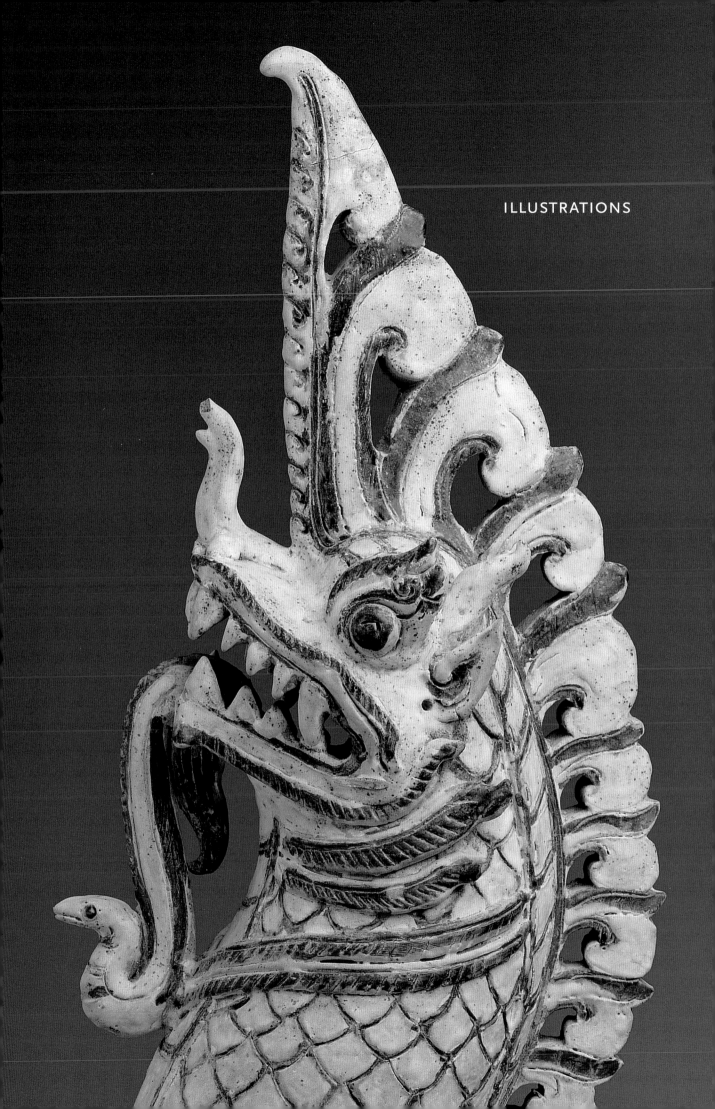

Iban ceremonial blanket (pua)
Sarawak, Malaysia

Pua were used traditionally in ceremonies associated with birth and death, to define ritual space, and to wrap those seeking contact with the spirit world. The design of this twentieth-century *pua* features human figures (*engkaramba*), which had a protective function and whose use was once restricted to the wives and daughters of chiefs. Their use is now more widespread as these dynamic figures appeal strongly to the tourist market.

Cotton, warp ikat, made by an Iban woman in Sarawak, Malaysia, 1920–1950. 251 x 113 cm. 94/42/1, gift of Alastair Morrison under the Taxation Incentives for the Arts Scheme, 1994. CS

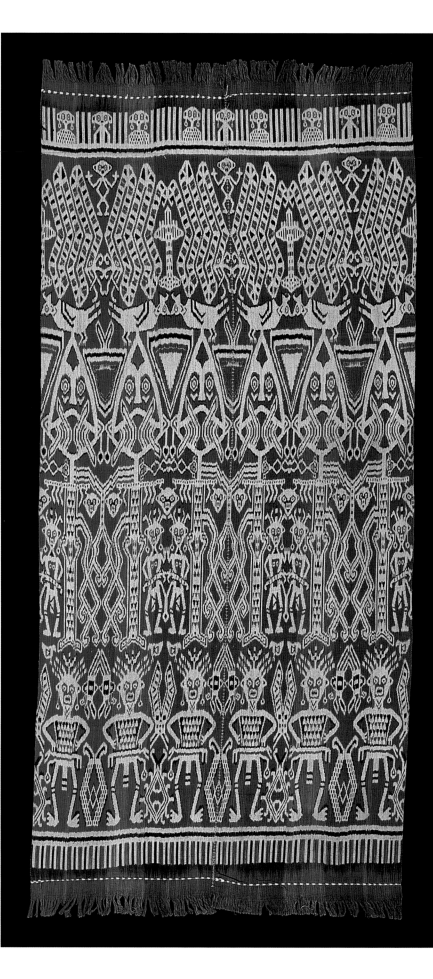

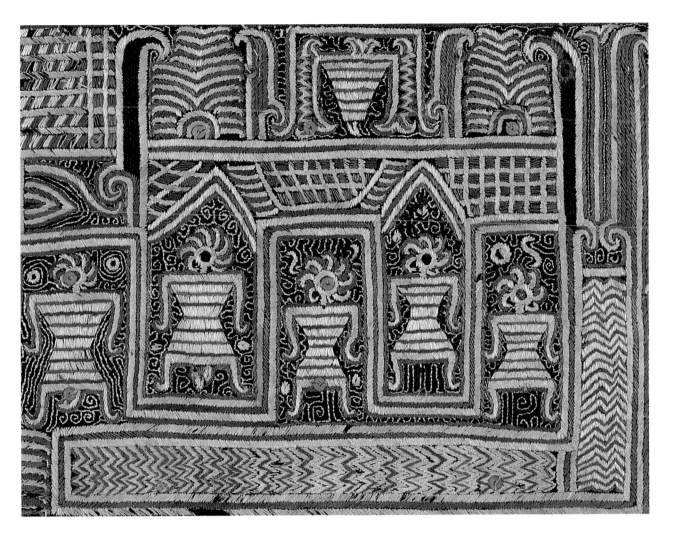

Section of a woman's ceremonial skirt *(tapis inuh)* Sumatra, Indonesia

This elaborately embroidered cloth would originally have formed part of a woman's prized ceremonial skirt known as a *tapis inuh*. Decorative panels such as this were inserted into the upper and lower sections of cylindrical skirts. The textile depicts stylised figures alongside banners (detail above), trees of life and archaic spiral and buffalo-horn motifs relating to animist beliefs.

Cotton, silk, sequins, embroidery, made in the Lampung region, south Sumatra, Indonesia, 1880–1900. 62 x 16.5 cm. A8483. ME

Mat
Kalimantan, Indonesia

The design on this twentieth-century mat can be read in either direction from the large central serpent. It incorporates sacred and secular as well as local and imported elements including a cosmic tree, anthropomorphic figures, hornbills, text and flowers with hovering butterflies. The ship, a symbol of change, is here combined with a serpent to create a dragon-boat shape.

Rattan, plaiting, made by Dayak people in central Kalimantan, Indonesia, about 1920. 186 x 108 cm. A10997. ME

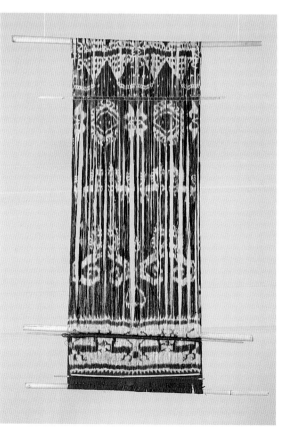

Ikat-dyed warp
Sumba, Indonesia

Warp ikat involves the tying and dyeing of the warp (lengthwise) threads with the design for a textile prior to weaving. Shown here are the threads prepared for a continuous warp ikat from Sumba.

Bamboo, handspun cotton, warp ikat, made in Sumba, Indonesia, 1900–1940. 140 x 103 x 3 cm. 89/259:1–6. ME

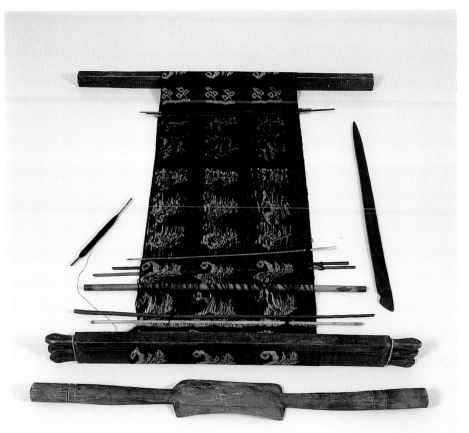

Body-tensioned loom
Flores, Indonesia

Body-tensioned looms are used throughout Southeast Asia. In this example, the wooden back support is curved to fit the weaver's body. The support is attached to the breast beam with ties and the far end of the loom secured. The weaver controls the tension of the warp threads by the degree of pressure on the wooden support as she leans back. Partially completed on this loom is the continuous warp for a warp ikat cloth.

Wood, bamboo, cotton, warp ikat, made in the Sikka district of Flores, Indonesia, 1900–1940. 162 x 133 x 7.5 cm. 85/723. ME

Skein holder
Sumba, Indonesia

Once thread or yarn has been measured in preparation for weaving, it is wound around the arms of a skein holder. The arms of the holder then rotate around its central shaft as the skein is wound off into a ball. The top of the central rod and the ends of three of this skein holder's arms are decorated with carved human faces (see detail).

Wood, carving, made in Sumba, Indonesia, 1860–1900. 51 x 63 x 63 cm. 89/260. ME

Woman's skirt *(bidang)*
Sarawak, Malaysia

Iban motifs are traditionally
handed down from mother to
daughter. Most are derived
from human and animal forms,
trees and plants, and everyday
items. The principal motif in
this *bidang* is the *rusa* or deer.
Spirals and hooks, reminiscent
of ancient Dong Son patterns,
are integral to the overall
design. Iban women wear
the *bidang* wrapped around
the body with a corset of split
rattan rings, a jacket and heavy
jewellery at neck and ears.

Cotton, warp ikat, indigo-dipped
selvedges, made by an Iban woman
in Sarawak, Malaysia, 1900-1940.
113 x 58 cm. A7966-5. cs

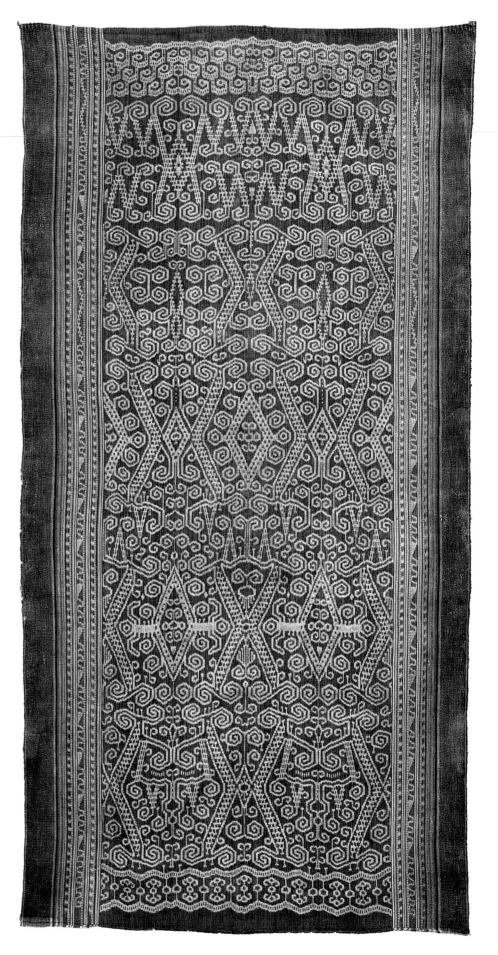

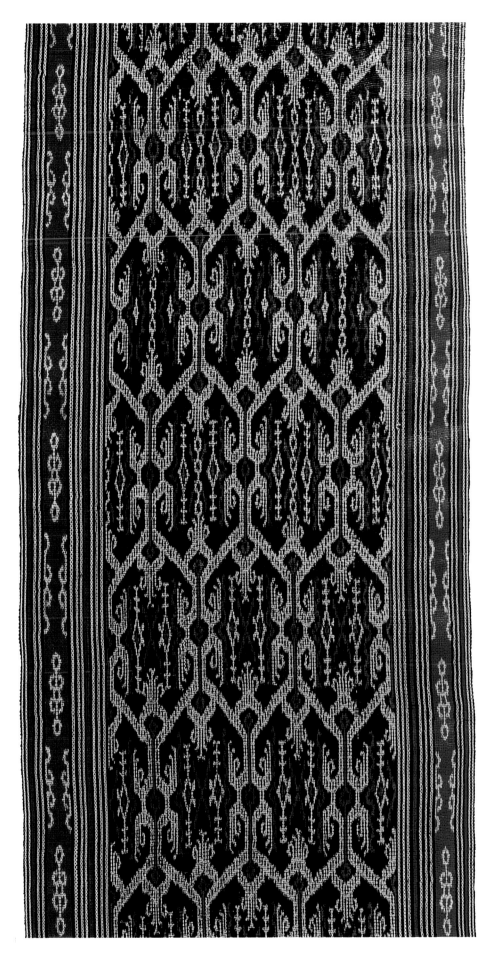

Warp ikat length
Mindanao, Philippines

The use of warp ikat to pattern banana fibre cloth was practised by the Bogobo, Bilaan and T'boli peoples of the southern Philippines. The patterns created by T'boli weavers are said to show stylised house structures with people inside. Pieces of cloth like this were sewn lengthwise in threes to make ceremonial blankets called *kumo*, which were traditionally given to the bridegroom's family at T'boli weddings.

Banana fibre *(Musa textilis* or *abaca)*, warp ikat (T'boli: *më-bëd*), made by a T'boli woman in Cotabato province, south-west Mindanao, Philippines, 1900–1950. 150 x 54 cm. 85/645. CS

Ceremonial textile *(ulos ragi hidup* or *ulos ragidup)*
Sumatra, Indonesia

The Toba Batak people have a rich and complex system of spiritual beliefs central to which is the complementarity of opposites. Bands of woven pattern define one end of this sacred ritual cloth as male and the other as female. The male is identified by a series of triangular shapes while the female end features diamond-shaped motifs. Toba Batak patterns are closely aligned with ancient Dong Son designs.

Cotton, natural and synthetic dyes, warp ikat, supplementary weft and warp weaving, twining, made by Toba Batak people in north Sumatra, Indonesia, 1900–1925. 208 x 117 cm. A9624. ME

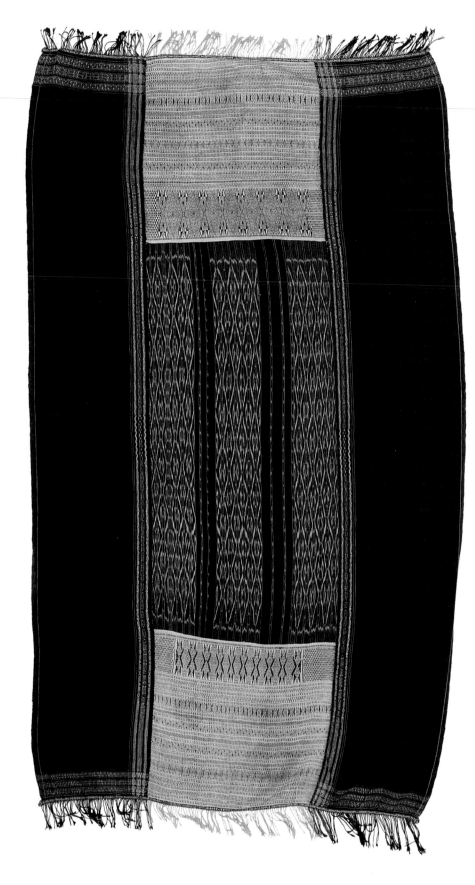

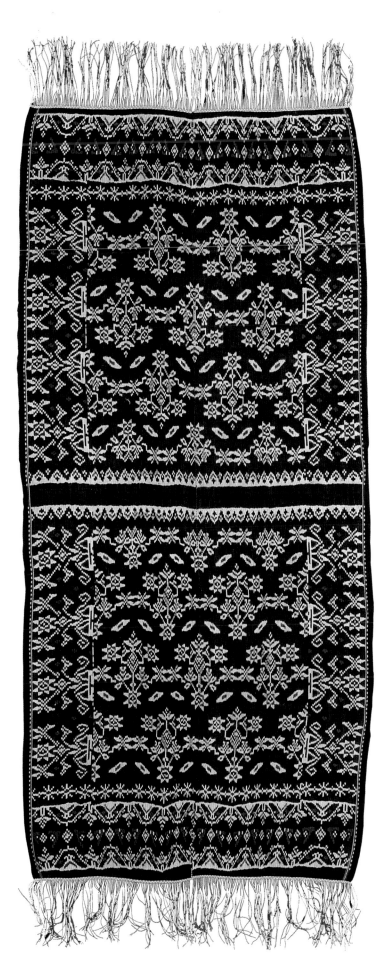

Mantle *(selimut)*
Roti, Indonesia

The floral design on this man's cloth shows the influence of the prestigious and sacred silk double ikat *patola* cloths made in Gujarat in India and traded to Southeast Asia. The borders, triangles, eight-pointed stars and grid format of the cloth all derive from *patola* design. On the island of Roti, *patola*-inspired patterns were associated with royalty and were applied to locally woven textiles to indicate nobility and power.

Cotton, warp ikat, made in Roti, Indonesia, 1900–1940. 200 x 81 cm. 85/748. ME

Sacred textile *(geringsing cicempaka petang dasa)*
Bali, Indonesia

Attributed with powerful magical and protective qualities, *geringsing* are worn as ceremonial clothing and used in rites of passage, as well as in offerings to Hindu gods. The Balinese village of Tenganan is the only place in Southeast Asia where textiles are traditionally made using an elaborate double ikat patterning technique involving tying and dyeing both the warp and weft threads with the design before weaving.

Cotton, double ikat, made in the village of Tenganan Pegeringsingan, eastern Bali, Indonesia, 1890–1920. 191.5 x 61 cm. A10982. ME

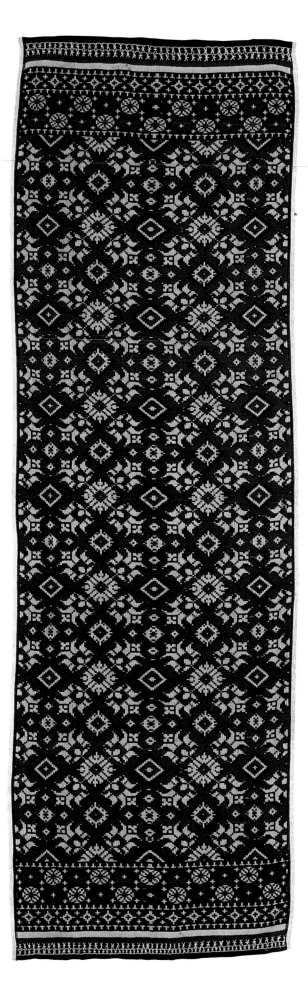

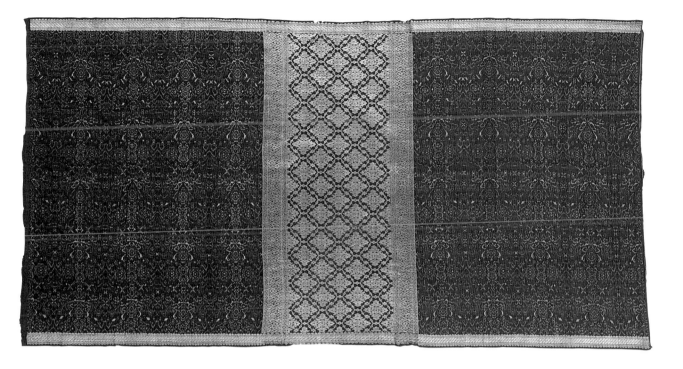

Man's sarong *(kain limar)*
Malay peninsula

In the hierarchical Malay courts where Indian ideas of kingship had taken root, prestige and wealth were inherited rather than acquired. Fine textiles such as this one thus became important as symbols of rank and status rather than for any ritual significance. This sarong was made for court or official wear on ceremonial occasions. The gold panel (see detail) would be arranged at the back.

Silk and gold-wrapped thread, weft ikat *(limar)* and supplementary weft *(songket)*, made in Terengganu, east Malaysia, about 1900. 206 x 104 cm. A10589. cs

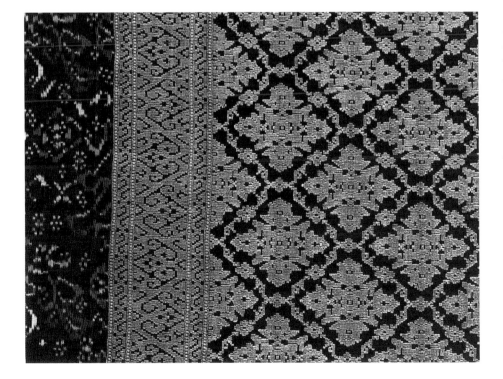

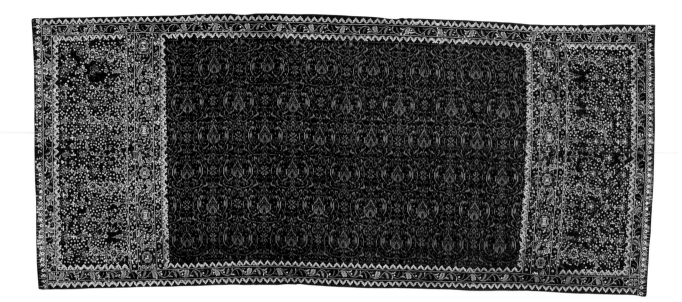

Ceremonial shoulder cloth
(kain limar)
Sumatra, Indonesia

Trade relationships and the
Chinese presence in Southeast
Asia have resulted in
considerable Chinese influence
on the court textiles of Sumatra
and the Malay peninsula. Richly
embroidered with floral motifs
and metallic thread (see details
below), the borders of this cloth
are distinctly Chinese in style.
The winged motifs in the central
area of the cloth are stylised
garudas. The *garuda*, a mythical
Hindu bird, is the adopted
symbol of many Southeast
Asian courts.

Silk, metallic thread, metal sequins,
weft ikat *(limar)*, embroidery, made by
Malay people in the Palembang region,
south Sumatra, Indonesia, about 1900.
195 x 84.5 cm. 94/42/3, gift of Alastair
Morrison under the Taxation Incentives
for the Arts Scheme, 1994. ME

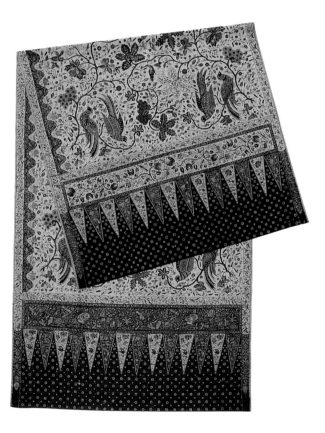

Skirt cloth *(kain panjang)*
Java, Indonesia

The finely drawn bird and
foliage design on this batik
cloth appears to be inspired by
the Coromandel Coast chintzes
traded to Indonesia from India
and also popular in Europe.
The row of triangles along the
head panel also derives from
Indian models and is
characteristic of Javanese
batiks from Chinese
workshops. Dyeing the head
blue at one end and red at the
other is another particularly
Chinese practice.

Cotton, batik, made by Peranakan
Chinese people in Lasem, north Java,
Indonesia, about 1900. 261 x 104 cm.
85/1752, gift of Mrs Leslie Campbell-
Brown, 1985. ME

44

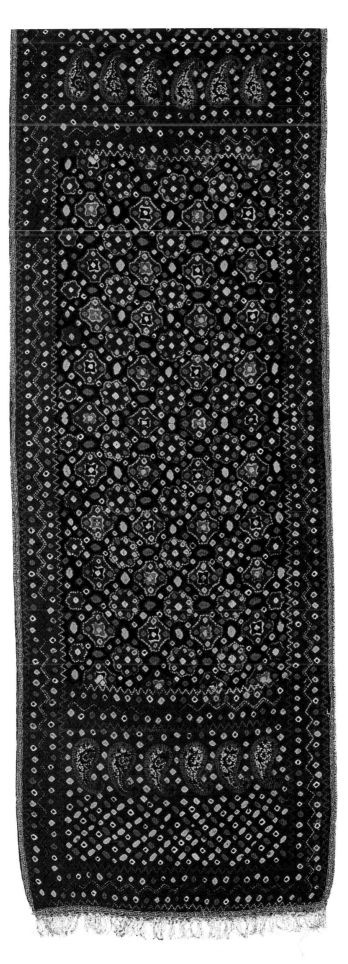

Shouldercloth and shawl (plangi)
Sumatra, Indonesia

Plangi, the Indonesian word for rainbow, is also the term used to describe tie-dyed textiles. Almost all Palembang *plangi* are created according to a particular design format, of which this cloth is an example. The cloths have a border of Kashmiri cone motifs, spots and zigzags and frequently include a star-covered centre. This edge of this *plangi* is embellished with copper thread.

Silk, cotton, copper thread, tie dyeing (*plangi*), stitch resist (*tritik*), made by Malay people in the Palembang region of south Sumatra, Indonesia. 1900–1925. 228 x 78 cm. 85/747. ME

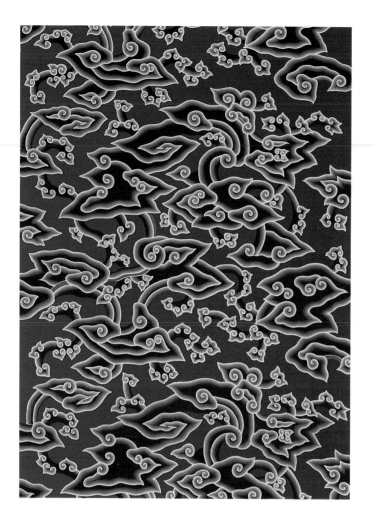

Skirt cloth
(kain panjang) detail
Java, Indonesia

Inspired by Chinese imagery, this design is called *megamalang*, meaning 'clouds lying flat or horizontal'. Production of this pattern virtually ceased before World War II and old examples of the style are scarce. This piece, made in 1983 by artists at Trusini, a small community on the outskirts of Cirebon, illustrates a revival encouraged by recent foreign interest in Cirebon batik.

Cotton, batik, made in Trusini, Cirebon, Java, Indonesia, 1983. 252 x 103.5 cm. 85/207. ME

Sarong *'Parang kembang' detail* by Agus Ismoyo and Nia Fliam
Java, Indonesia

Agus Ismoyo and Nia Fliam established the Brahma Tirta Sari Studio in 1985. The studio creates contemporary textiles drawing on the philosophical as well as the creative processes of Javanese batik tradition. Their *parang kembang* design combines elements of the *parang*, a traditional motif symbolising a weapon or flame, with the strength and beauty of a flower, *kembang*.

Silk, batik, made in the Brahma Tirta Sari Studio in Yogyakarta, central Java, Indonesia, 1993. 120 x 230 cm. 94/50/1. ME

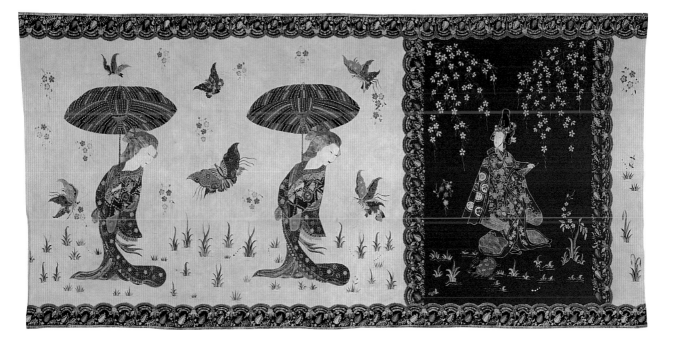

Skirt cloth *(kain sarong)*
Java, Indonesia

With its unusual design of
kimono-clad Japanese women,
this sarong is indicative of the
cross-cultural trade in images
and ideas between east and
west. Made in Java in a Euro-
Javanese workshop, it reflects
the strong interest in Japanese
art and particularly woodblock
prints, in the late 1800s and
early 1900s.

Cotton, batik, made in north Java,
Indonesia, 1880–1920. 103 x 212 cm.
94/124. ME

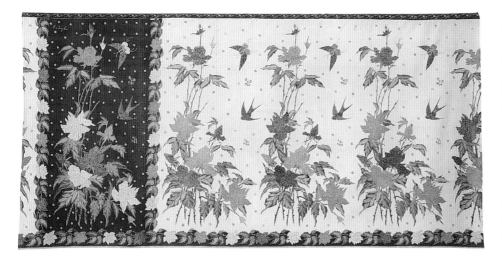

Skirt cloth *(kain sarong)*
by Eliza van Zuylen
Java, Indonesia

Made in the studio of Eliza
van Zuylen, a Dutch woman
who ran a batik business in
Pekalongan between 1890 and
1946, this sarong's design of
bouquets, birds and butterflies
draws inspiration from both
European and Chinese sources.
Although historically the names
of batik makers are rarely know,
the work from van Zuylen's
studio is always signed.

Cotton, batik, made in the studio of
Eliza van Zuylen in Pekalongan, north
Java, Indonesia, about 1910. 107 x 212
cm. 85/1074. ME

Heirloom cloth
(mawa or ma'a)
Sulawesi, Indonesia

Textiles traded from India are considered sacred heirlooms in parts of Indonesia. Inspired by Indian design and production techniques, the Toraja have created painted and block-printed cloths to complement and replace their precious Indian pieces. This cloth features a central tree, an ancient symbol of fertility and regeneration, at the base of which is a village scene depicting villagers, houses, chickens and buffalo.

Cotton, painting, drawing, block printing, made by Toraja people in central Sulawesi, Indonesia, 1900–1920. 318.5 x 85 cm. A10994. ME

Far right
Heirloom cloth
(mawa or ma'a)
Sulawesi, Indonesia

Mawa or *ma'a* textiles are family treasures used to sanctify rituals surrounding birth, death and fertility. The central stamped motif of this cloth shows herders driving long-horned buffalo through the gates of a circular corral populated by birds and other small forms. Buffalo are central to the Torajan economy and often appear on their important textiles.

Cotton, painting, stamping, made by Toraja people in central Sulawesi, Indonesia, 1900–1925. 304 x 67 cm. A10704. ME

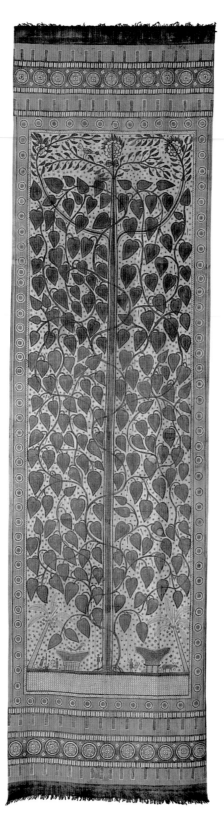

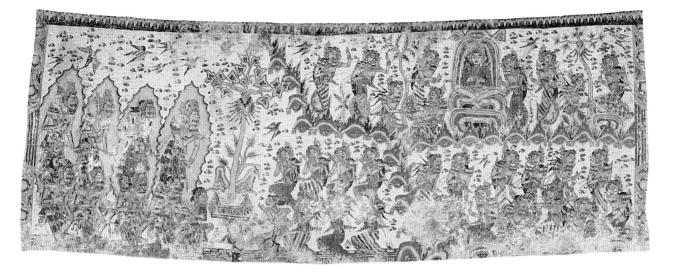

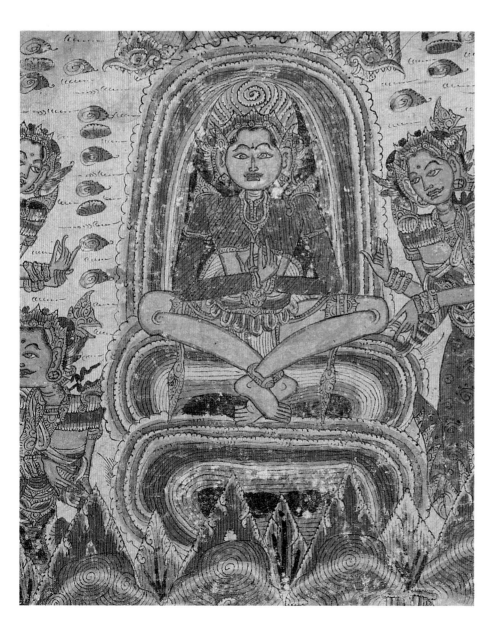

Painted ceremonial curtain
(langse)
Bali, Indonesia

Langse are rectangular cloths which are hung as curtains or screens in temples, houses and other places of ritual in Bali. The scene on this cloth is called *Arjuna Matapa* and depicts the life of Arjuna, a hero from the Indian epic the *Mahabharata*. The detail shows Arjuna meditating. In Bali and Java, local stories and aspects of Buddhist philosophy have been incorporated into the Hindu *Mahabharata*.

Cotton, rice paste, ink, paint, made in Kamasan, Bali, Indonesia, 1920–1940. 90 x 243 cm, 2000/72/13, gift of Gisella Scheinberg under the Cultural Gifts Program, 1999. ME

Wall hanging (kalaga) details
Burma

Decorative hangings such as
this one, typically with
narratives illustrated in narrow
bands, were used in Buddhist
Burma as furnishings, for
ceremonial display, and as gift
offerings to local monasteries
in order to gain merit. The
Jataka tales, about the earthly
life of the Buddha Shakyamuni,
are common subject matter for
kalagas, whose lively
illustrations portray many
aspects of Burmese everyday
and court culture.

Velvet, cotton, sequins, couching and
appliqué embroidery, made in Burma
about 1900. 50.5 x 381 cm. 85/313-1. CS

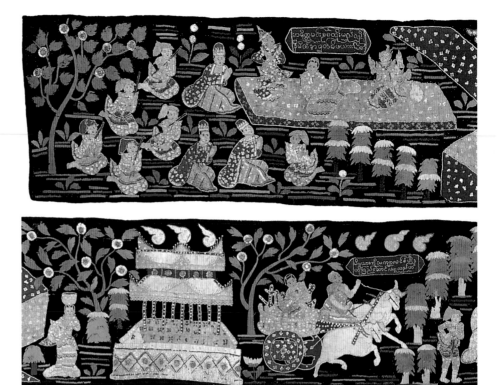

Painted hanging *(ider ider)*
details
Bali, Indonesia

Long and narrow, pictorial *ider
ider* valances are hung
horizontally beneath the eaves
of temples and pavilions in Bali
during festivals and other
ceremonial occasions. This *ider
ider* depicts Bima's travels to
the underworld from the
popular Indian epic the
Mahabharata.

Cotton, rice paste, ink, paint, made in
Kamasan, Bali, Indonesia, 1880–1900.
25 x 397 cm 2000/72/5, gift of Gisella
Scheinberg under the Cultural Gifts
Program, 1999. ME

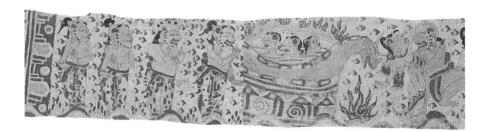

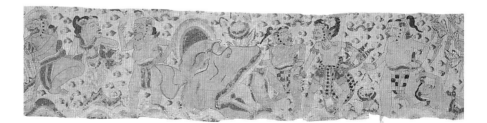

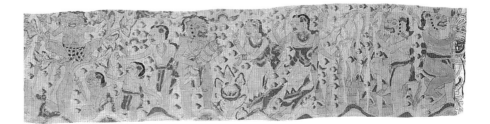

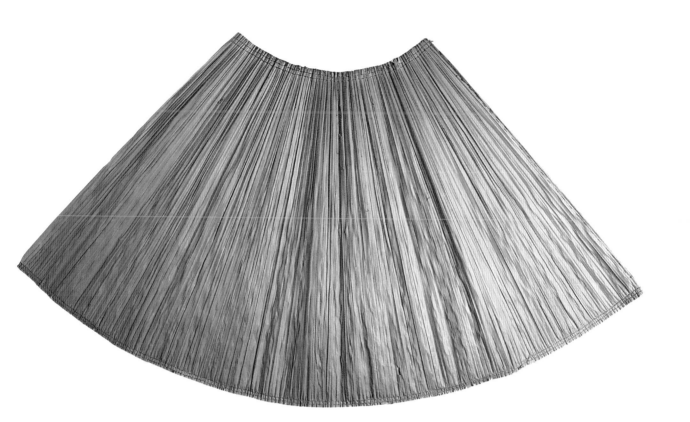

Rain cloak
Kalimantan, Indonesia

Made from leaf fibre sewn together in two fan-shaped sections, this cloak offers protection from the rain and may also possess ritual significance. Clothing made from leaf and plant fibres stems from the earliest times, its size, shape and form prescribed by the materials used. Although they are incorporated into certain ceremonies as providers of symbolic protection, leaf-fibre cloaks for practical use are now scarce in Indonesia.

Leaf fibre, cotton thread, fibre thread, made in Kalimantan, Indonesia, 1960–1980. 64 x 130 cm. 89/775. ME

Shrine hanging *(lamak)*
Bali, Indonesia

Dewi Sri or cili, the Hindu goddess of rice and fertility, is widely worshiped for her life-giving qualities and can be clearly seen on this cloth. Used in Bali to embellish shrines, altars and temple doors and hung as banners, *lamak* are central to many temple ceremonies. The piece of mirror below Dewi Sri is thought to deflect evil.

Cotton, silk, velvet, sequins and mirror piece, appliqué and mirror work embroidery, made in Bali, Indonesia, about 1950. 167 x 19.5 cm. A8485. ME

Woman's embroidered
blouse *(albong ansif)* and
man's embroidered
trousers *(sawal ansif)*
Mindanao, Philippines

The Bilaan believed that fine
clothing was indicative of fine
character and Bilaan women
therefore invested considerable
effort in their embroidery *(ansif)*.
The cross-like motifs on the
bodice may be identified as
crocodiles, which act as charms
to ward off danger. The Bilaan's
headhunting history is reflected
in the red of the *albong* bodice.
Red represents the blood of
slain victims, offered as sacrifice
to appease the spirits.

Banana fibre *(Musa textilis* or *abaca)*,
warp-faced plain weave, hand sewn with
cotton embroidery, made by a Bilaan
woman in south Mindanao, Philippines,
1900–1950. Shirt: 51 x 121 cm. 94/3/4;
trousers: 48 x 65 cm. 94/3/3. CS

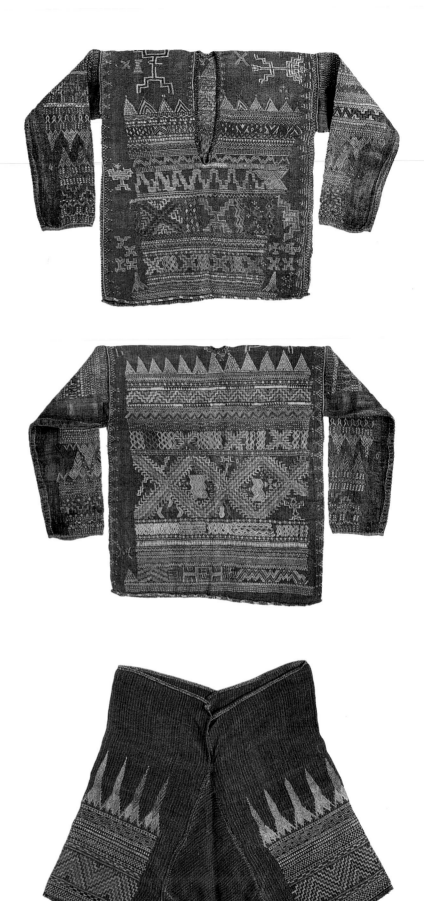

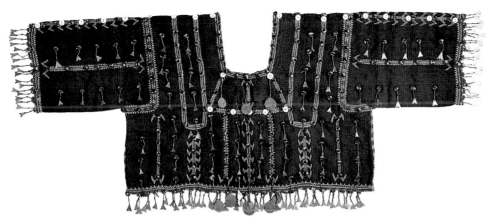

Woman's embroidered blouse *(badu)*
Luzon, Philippines

Ilongot women were skilled embroiderers and developed a repertoire of finely detailed decoration for their upper garments, wrap-around skirts and loincloths. These were made from trade cloth, as the Ilongot were not themselves weavers. The use of exquisitely tiny stitches and ornaments reflects the general importance accorded to detail in Filipino textiles and language. The blouse's tailored form reflects cross-cultural influences.

Indigo-dyed cotton trade cloth, wool, brass, mother of pearl, embroidered by an Ilongot woman in eastern Luzon, Philippines, 1910–1950. 35 x 83 cm. 94/3/2. CS

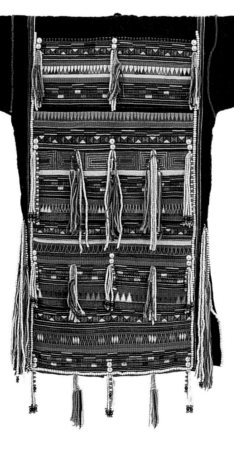

Woman's jacket
Thailand

The Loimi-Akha are a Tibeto-Burman people who probably originated in Yunnan and entered northern Thailand from neighbouring Burma about 1900. They are animists, who emphasise ancestor-worship and adhere to strict customary laws which they call the 'Akha way'. Akha women are known for their remarkable dress and wear jackets like this one with embroidered leggings, skirt, sash and a fabulous silver headdress.

Indigo-dyed cotton, metal studs, 'Job's tears' seed beads, couching, herringbone, chain stitch and appliqué embroidery, made by a Loimi-Akha woman in north-east Thailand, about 1940. 79 x 138 cm. A7338. CS

Woman's ceremonial
jacket *(sapé manik)* and
skirt *(kain manik)*
Kalimantan, Indonesia

As exotic trade items, beads
are credited with magical and
protective qualities throughout
Kalimantan. Beading adds to
the value, strength and ritual
significance of garments. The
Maloh women of west
Kalimantan wear heavily
beaded jackets and skirts for
ceremonial purposes. The
decorative hook-and-rhomb
design on this jacket and skirt
derives from serpent *(naga)*
and mask *(udo)* images.

Beads, shells, sequins, coins,
medallions, cotton, beadwork and
appliqué, made by a Maloh woman in
west Kalimantan, Indonesia, 1900–1940.
Jacket: 45.5 x 38 cm; skirt: 54 x 41.5 cm.
A10928-1, A10928-2. ME

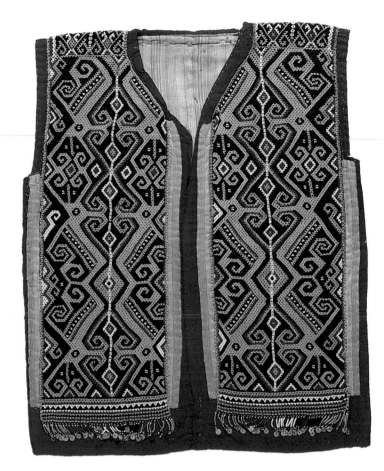

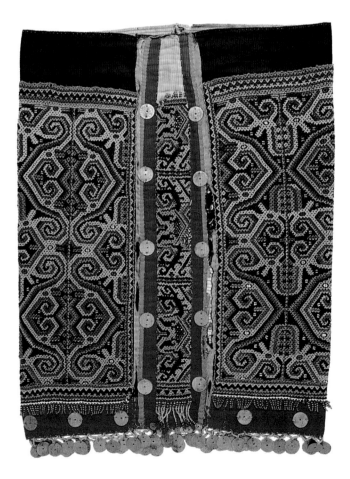

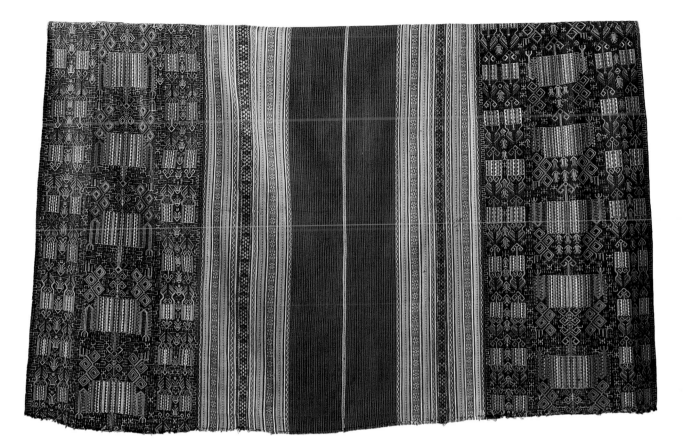

Woman's ceremonial skirt *(tais)*
West Timor, Indonesia

This skirt cloth consists of four panels stitched together. The heavily patterned areas at either end are created using a complicated technique involving wrapping the warp threads in coloured wefts during the weaving process. The motifs on this skirt include stylised human forms, hooks, rhombs and spirals.

Cotton, supplementary weft wrapping *(buna)* and warp floats, made in the Belu region, West Timor, Indonesia, about 1940. 107 x 165 cm. 85/648. ME

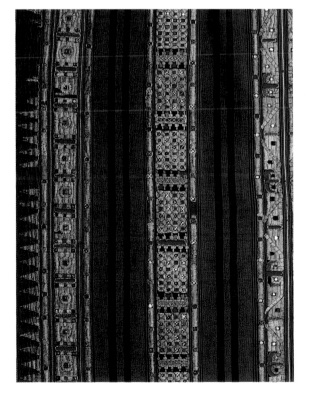

Woman's ceremonial skirt *(tapis) detail*
Sumatra, Indonesia

Richly embroidered cylindrical skirts such as this one are worn by noblewomen on ceremonial occasions. Lampung *tapis* skirts are renowned for their exquisite couched metallic thread embroidery. The glittering decoration appears all the more sumptuous against the simple brown warp-striped base cloth that provides the foundation for most such skirts.

Silk, cotton, metallic thread, beads, sequins, mirror pieces, appliqué and couching embroidery, made in the Lampung region, south Sumatra, Indonesia, about 1900. 118 x 123 cm. A7966-21. ME

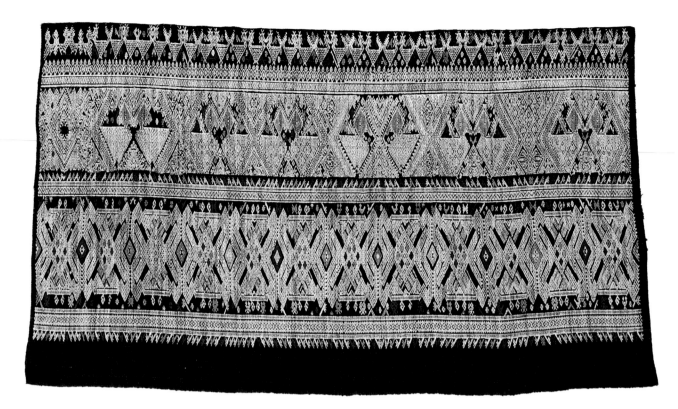

Wedding skirt *(pha sin)*
Laos

Special skirts for bridal wear were traditionally woven with intricate all-over supplementary weft patterning. Typically they featured auspicious symbols such as the peacock (see detail), a symbol of good luck and prosperity, here arranged face-to-face in the upper half of the skirt. A complex arrangement of Dong Son-style abstract geometric motifs decorates the lower half.

Red silk warp, indigo cotton weft, cotton and silk supplementary wefts, made by a Tai Daeng woman in Sam Neua, north-east Laos, about 1900. 73 x 127 cm. A11075. CS

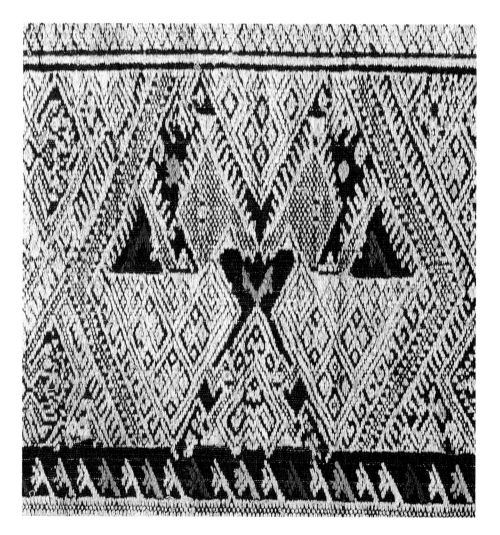

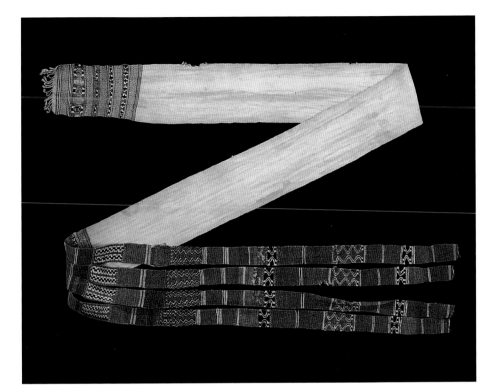

Ritual belt or sword decoration *(pilu saluf)* Timor, Indonesia

Long cloths such as this one were worn in a variety of ways, primarily as belt or sword decorations, as part of the elaborate ritual costume of *méo* warrior leaders in Timor. The predominance of red in this cloth is probably due to the warrior-like qualities the colour implies throughout Southeast Asia.

Cotton, silk, tapestry weave, twining, made by Atoni or Dawan people in Timor, Indonesia, early 1900s. 199 x 10 cm. A8491. ME

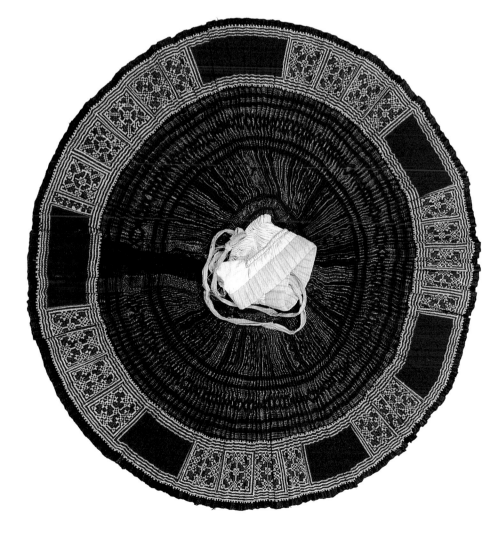

Woman's skirt made by Nang May Chang Laos

The Hmong people came to north Laos from south-west China. The women possess exceptional costume-making skills, which are passed on from mother to daughter. Pleated skirts like this are traditionally made from hemp and differ in detail and ornament from subgroup to subgroup. They are worn with embroidered jacket, leggings, apron and sash. The maker, Nang May Chang, belongs to the Blue Hmong subgroup.

Hemp and cotton, indigo-dyed batik, appliqué and cross-stitch embroidery, made in Bahn Phan Sawan village, Hua Phan province, north Laos, about 1980. 126 x 126 cm. 2000/101/1. CS

Woman's shoulder cloth
(pha biang)
Laos

Red-ground shoulder cloths such as this one were among the most exact and elaborate of all textiles made by Tai Daeng women, who wore them diagonally (*biang*) across the chest on special occasions. The diamond pattern (*douang tda*) is sometimes associated with Buddhist meditation practice. Beneath it are male and female long-nosed mythical *kosa-sing*, with spirit beings on their backs as symbols of transition.

Zone-dyed silk warp, silk and cotton supplementary wefts, added fringe, woven by a Tai Daeng woman of Houa Phan province, north-east Laos, about 1900. 235.8 x 43 cm. A11074. cs

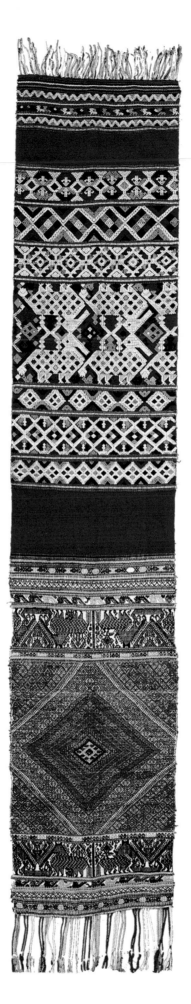

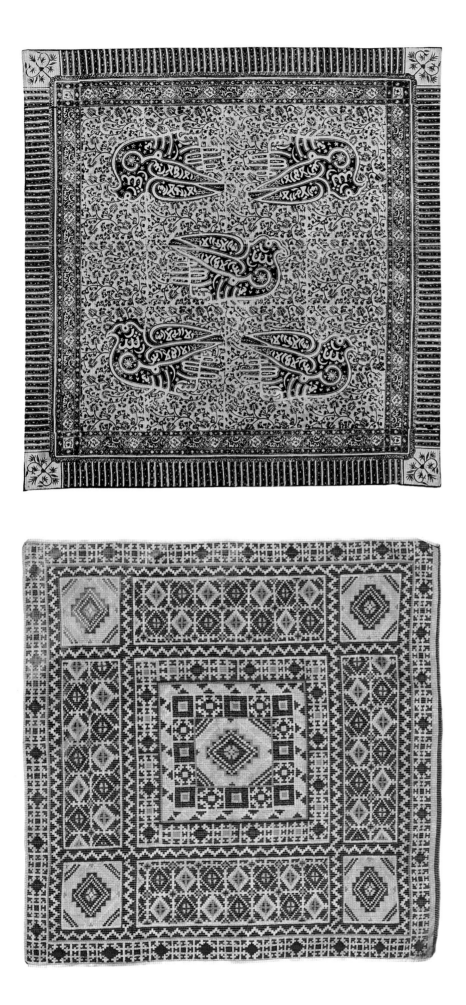

Man's headcloth
Java, Indonesia

The influence of Islam in Indonesia can be clearly seen in this batik headcloth with bird-shaped Arabic calligraphic inscriptions. Made in Java, it was probably produced for the Sumatran market where such items enjoyed considerable popularity. Headcloths, which are better suited to the tropical climate than the turban favoured elsewhere, are worn by Muslim men throughout Southeast Asia.

Cotton, indigo, stamped batik and drawing, made in Java, Indonesia, mid 1900s. 90 x 91 cm. A10014. ME

Man's headcloth
(pis siyabit)
Sulu archipelago, Philippines

Square headcloths such as this one were typically worn by Muslim men. In headcloths from the Sulu archipelago, tapestry weave (siyabit) was combined with geometric patterns, which are universally acceptable to Islam. Sulu was one of the earliest Islamic centres in Southeast Asia. Its sultans were heavily involved in international trade, importing luxury textiles that included double ikats from India and tapestry weaves from China.

Silk, tapestry weave, made by the Islamic Tausug people in Jolo, Sulu archipelago, south-west Philippines, about 1920. 91 x 90 cm. 85/646. CS

Two hats
Burma and Indonesia

Wide-brimmed hats made of plant fibres are traditional everyday wear for working people throughout Southeast Asia. The hat *(right)* is of the type worn by farmers and fishermen in the Inle Lake region of Burma and was bought at a floating market in nearby Taungye in 1987. The very finely plaited hat *(below)* was made in Java for the export market during the latter years of the Dutch administration.

Plant fibre, probably made near Inle Lake, central Burma, in 1987. 15.2 x 40.8 x 40.8 cm. 96/374/5, gift of Lyn Bootes, 1996.

Bamboo, plaited, made in Java about 1920. 27 x 36 x 36 cm. D9692-5, gift of P E Teppema, Consul General of the Netherlands, 1924. CS

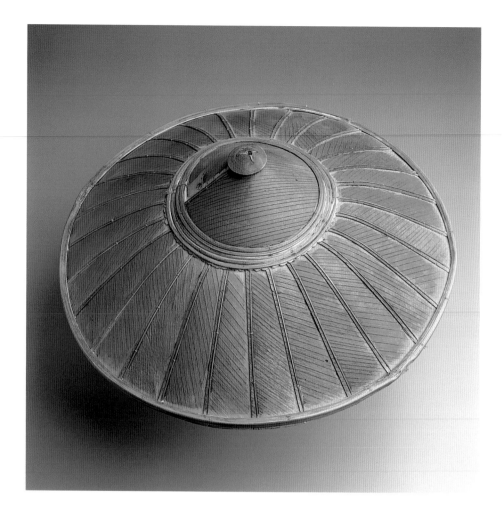

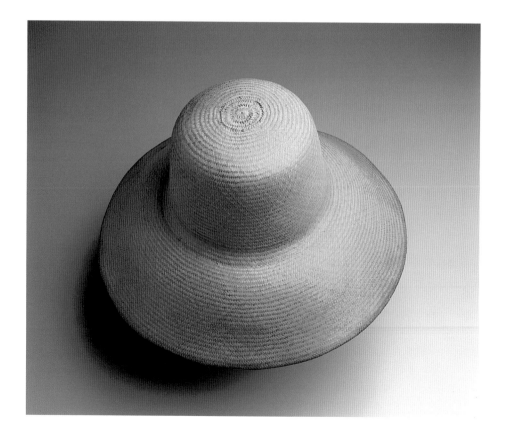

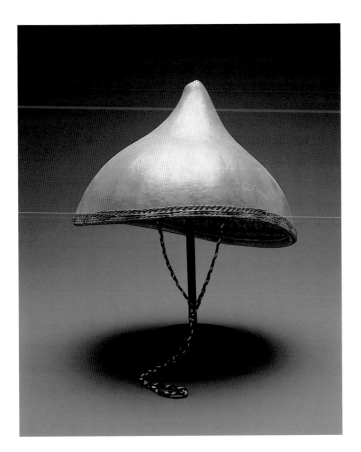

Two hats
Philippines

Everyday work hats for local use are usually made from readily available materials. The simple form of these two hats, which were worn by people engaged in agriculture and fishing, reflects their utilitarian function. The materials used are gourd *(left)*, bamboo and coconut fibre *(below)*.

Gourd, bamboo, cotton braid, made in the Philippines, about 1980. 24.7 x 34 x 34 cm. 96/345/3.

Coconut fibre, bamboo frame, made in the Philippines, about 1980. 20.4 x 30.3 x 30.3 cm. 96/345/2, gifts of Lyndy Bowman, 1996. CS

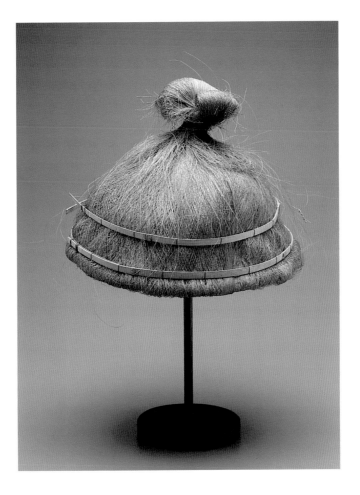

Woman's boots
Laos

These bright embroidered boots were made for a young Lao Hoay woman's wedding. They are decorated with tiny spiral motifs, archaic symbols of female fertility that have abounded as ornament in Chinese and Southeast Asian arts for at least 2500 years. Spirals are also found in the embroidery and appliqué of the Laotian Hmong who, like the Lao Hoay people, migrated south into northern Laos from China.

Cotton, chain stitch embroidery, quilted cotton soles, made by a Lao Hoay woman in Luang Nam Tha province, north-west Laos, 1985–1994. 12.5 x 9.3 x 23 cm. 94/263/1. CS

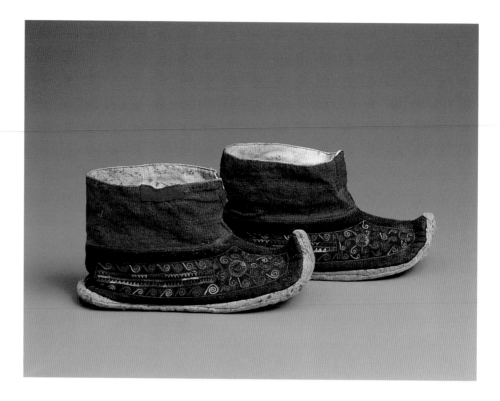

Woman's sandals
Burma

These finely stitched sandals were probably made for wear during the latter days of the Burmese court in the late 1800s. In 1886, after 60 years of dispute fuelled by British commercial interests, Burma was finally absorbed into British India and its last ruling Konbaung dynasty was dispersed. By 1895 the sandals were on display in London as part of the extraordinary collection of shoemaker Joseph Box.

Wool, leather, hand stitched, made in Burma,1850–1885. 23 x 9 x 4.5 cm. H4448-1023. CS

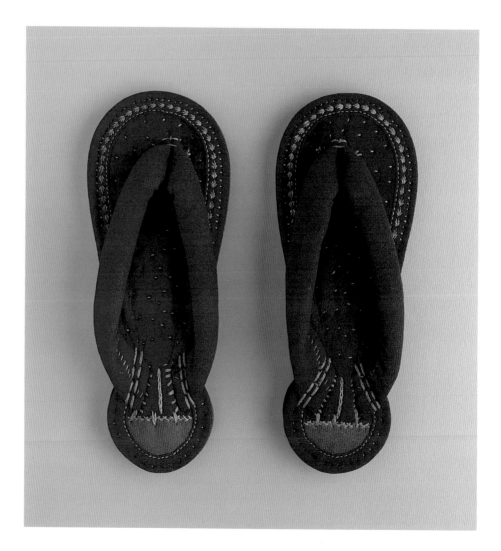

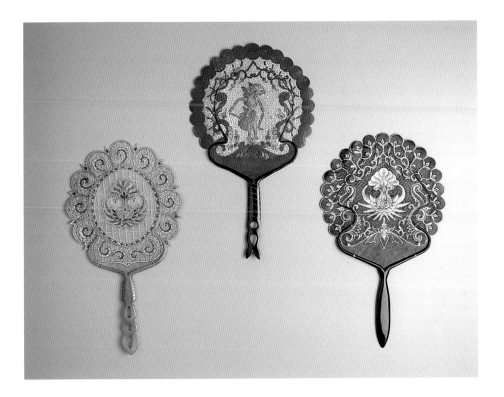

Screen fans
Sumatra, Indonesia

Parchment screen fans with scalloped edges are used as dance props all over Indonesia. They are made using the same techniques as those used to make leather shadow puppets or *wayang kulit*. Depicted in the middle of the central fan is a typical *wayang* puppet figure. The other two fans display double-headed bird motifs, representing the mythical *garuda*.

Pierced and painted buffalo parchment, carved horn, paint, gilding, made in Sumatra, Indonesia, 1880–1920. Centre: 30 x 18 cm. H6286, gift of Miss Imogen Wyse, 1959; left and right: 30 x 17.5 cm. A5409-2. 31 x 18.5 cm, A5409-4, gifts of Mrs C R Thornett, 1967. ME

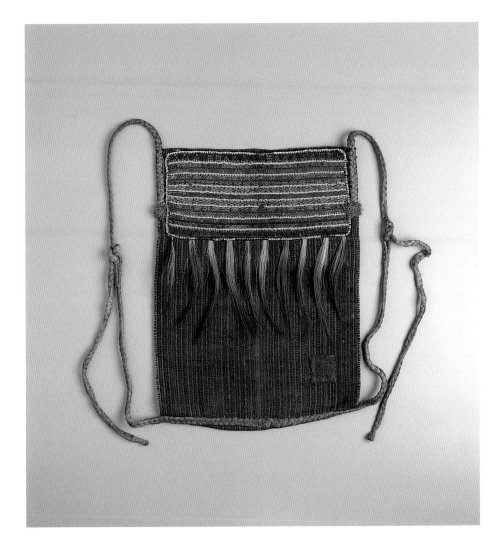

Backpack for betel
Mindanao, Philippines

Bags such as this one were used by the Bagobo people to carry the requirements for betel-nut chewing. This practice has a very long history in Southeast Asia and in many places betel was an important component of offerings to the gods. Consequently, the equipment associated with the custom, such as bags and cutters, took on ceremonial significance and were often beautifully made and decorated.

Banana fibre *(Musa textilis* or *abaca)*, trade beads, horsehair fringe, made by a Bagobo woman in south Mindanao, Philippines, 1900–1920. 53 x 40 cm. 85/744. CS

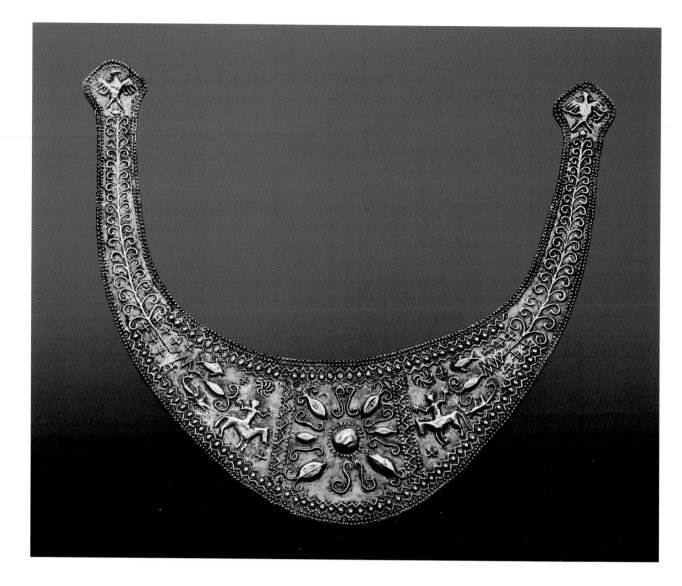

Man's headdress *(lamba)*
Sumba, Indonesia

Thought to resemble water
buffalo horns, *lamba*
headpieces are part of the
ritual royal regalia worn by
Sumbanese men. This *lamba*
has a central solar-style motif
flanked by horse and rider, as
well as scorpion, fish and bird
motifs. While textiles are
produced by women and
considered 'cold', 'hot'
metalwork is carried out by
men. Belonging to the
ancestral spirits, *lamba* are
said to 'glow with power'.

Sheet gold alloy, repoussé, made in
Sumba, Indonesia, 1880–1950.
20.3 x 24.5 cm. 89/1430. ME

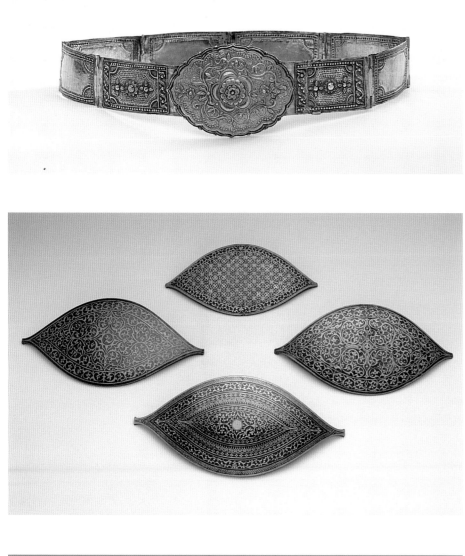

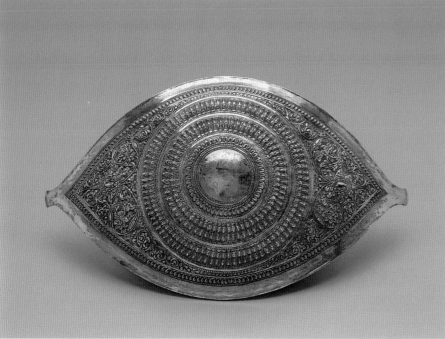

Belt
Java, Indonesia

With its ornate gold buckle and band of eight silver segments, this extravagant Javanese belt was probably made for a Chinese bridegroom living in Indonesia. Similar belts were also made by Chinese goldsmiths on the Malay peninsula and in Singapore. Although not common in China, belts were popular with Southeast Asian Chinese communities to fasten sarongs and denote wealth.

Gold, silver, repoussé, punching and engraving, made in Java, Indonesia, 1800–1930. 7 x 69 cm. A5807, gift of Mrs Mary Anne Robinson, 1970. ME

Four belt buckles (pinding)
Malay peninsula

The interlaced geometric patterns on these *pinding* are characteristic of Islamic art, which prohibited animal or human imagery. They are ornamented with *niello* work (black enamel is applied to the recessed surfaces of an object, fired to fuse the enamel and then polished). The Malays probably learned the art of *niello* from Thai artisans in Pattani.

Brass and enamel, *niello* work, made in the northern Malay peninsula, 1920–1925. 12 x 25.5 x 3 cm, 38a; 12.2 x 27 x 4 cm, 39a; 12 x 24.5 x 4 cm, 40a; 10.5 x 22.2 x 2.8 cm, 41a, gifts of FJ Benton, 1926. CS

Belt buckle (pinding)
Malay peninsula

Belt buckles like this were mainly worn by men on official occasions. Their size was an indicator of rank. They were typically made of silver, which was not indigenous to Malaysia. The finely embossed design is based on an open lotus flower surrounded by plant tendrils. In Perak, where this *pinding* was probably made, court regalia had magical connotations.

Silver, repoussé decoration, probably made in Perak, west-coast Malay peninsula, 1890–1920. 12 x 26.7 x 6 cm. 32a, gift of FJ Benton, 1926. CS

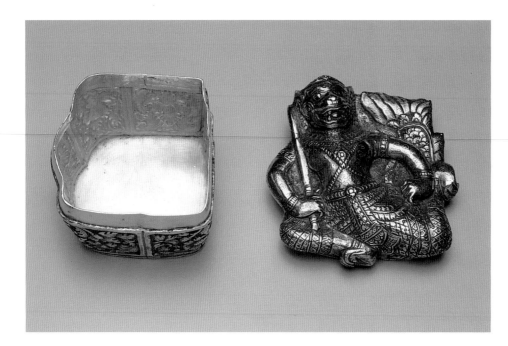

Silver cosmetic box
Cambodia

The lid of this small box shows Micheno, the fish-tailed child of Hanuman, the monkey king, and Supanamacha, his mermaid wife. Hanuman was a key figure in the Indian epic tale the *Ramayana*. Decorative boxes such as this usually took the form of astrological or mythological creatures like Micheno, although some are shaped like clam shells or pumpkins. They were used to hold cosmetics, lime or special potions.

Silver, repoussé decoration, made by a Khmer or Chinese silversmith in Phnom Penh, Cambodia, about 1900. 4.5 x 7.5 x 7.5 cm. A4138, gift of Hilda Marks, 1948. CS

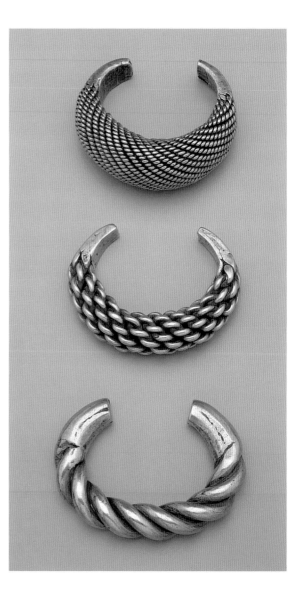

Men's bracelets
Laos

Twisted-wire bracelets such as these ones were worn by several of the tribal groups of northern Laos for whom silver jewellery represents wealth and status. They obtained Indian silver rupees and Burmese silver ingots through trade, melted them down and shaped them into the desired form. The upper two braided wire bracelets were probably worn by Akha men and the lower three-strand one by a Lawa man.

Silver, coiled wire, made by Akha and Lawa silversmiths in north Laos, 1900–1950. 8.5 x 6 x 1.5 cm 95/237/1; 8 x 6 x 2 cm 95/237/2; 7.6 x 6.3 x 2.6 cm 95/237/3. CS

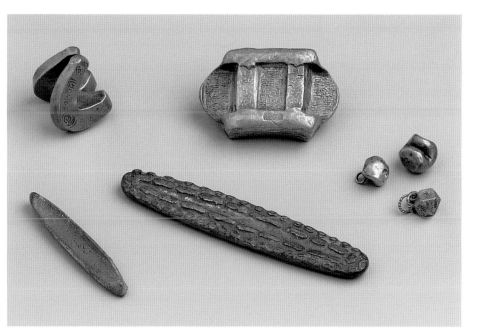

Representational money
Thailand, Vietnam and
Burma

Money in Southeast Asia took many imaginative and beautiful forms. Elephant-tusk money or *k'a k'im* is actually a bent form of bracelet cut to expose the silver. Saddle money is a type of ingot of Chinese origin that became popular in Thailand and Burma. The appropriately named canoes or *lats* of the Mekong Valley also come in less boat-like varieties, which are known as tiger-tongue money or ant-coins in reference to their raised patterning. The West likened bullet money to musket ammunition of the time. The Thais called them *p'ot duang* or curled worms.

Silver, copper-alloy, made in Thailand, Vietnam and China, used from the 1300s, these examples probably 1700s–1800s. Tiger-tongue money (centre front): 0.7 x 2.5 x 10.8 cm. Tiger-tongue, tusk and saddle money: 89/477-1:3, gifts of EA Crome 1989; canoe money: N20476, gift of N McGrath, 1975; bullet money: N6119, N6454, N14982, gifts of A Giles, 1945. PD

Three half mohurs
Java, Indonesia

These gold half mohurs combine three languages reflecting European trading interests and competition in Southeast Asia. Java became a Dutch trading colony in 1619 but was taken by the British in 1811 during the Napoleonic Wars. For a brief period afterwards these coins were made with script in Javanese, English, and Arabic until the treaty of Paris in 1814 when Java was restored to the Dutch. It remained a colony until 1949 when independence was obtained.

Gold, made at the Surabaya Mint in Java by Johan Anton Zwerkhert, 1811–1814. 2.1 x 2.1 cm. N15269, N15270, N15271, gifts of Dr G MacLeod, 1951. PD

Ceremonial dagger (kris)
Java, Indonesia

With its distinctive curved blade, the *kris* is a highly potent weapon, prized for its supernatural powers rather than its application in battle. Each *kris* is thought to possess a soul, is named and requires regular sacrifices and purification rituals. Treated well, a *kris* brings luck and protection from evil but if neglected it may cause adversity. In many Indonesian folktales people are saved by their *kris*.

Steel, ivory, gold, filigree, made in Java, Indonesia, late 1800s or early 1900s. 35 x 7.5 x 4 cm. A4381. ME

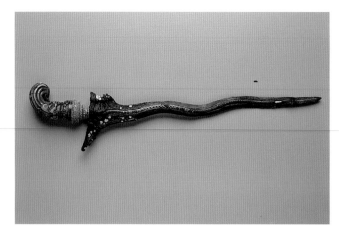

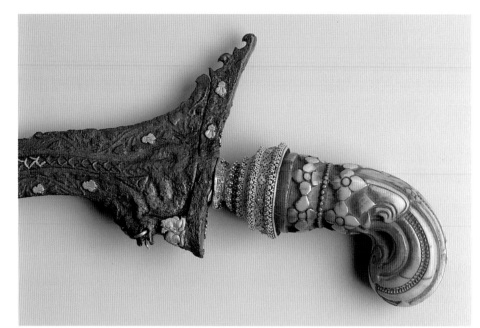

Sabre (klewang) and scabbard
Malay peninsula

For several hundred years an enormous variety of large- and small-hilted weapons have been made and used in the Malay peninsula. The blades are made from iron, which blacksmiths acquired through trade as it was not mined locally, and the grips and scabbards of silver. The *klewang* is one of the most frequently found forms. This example was found in Aceh in north Sumatra at the end of the Aceh War.

Watered iron, chiselled silver, wood, made in the Malay peninsula, 1880–1900. 3.5 x 69.2 x 9 cm. 42a, gift of FJ Benton, 1927. CS

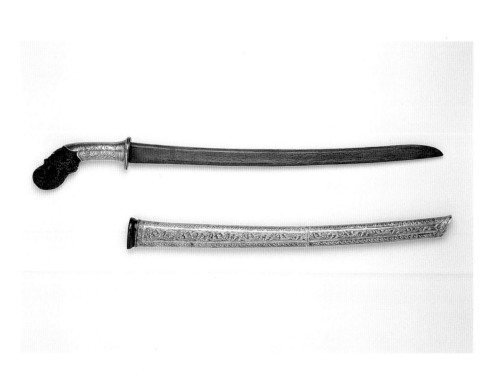

Quiver and darts
Kalimantan, Indonesia

Among its myriad uses, bamboo makes an excellent cylindrical container. This bamboo quiver was made to carry the slender darts for a Dayak hunter's blowpipe. As these darts were often treated with plant poison, they had to be carefully protected. The forked stick bound with plaited rattan to the base of the quiver was hooked through the hunter's belt for carrying.

Bamboo, rattan, made by a Dayak man in Mankassin village, Lubai River region, Kalimantan, Indonesia, 1850–1900. Quiver: 39.5 x 12 x 7 cm; darts: 22 x 0.3 x 0.3 cm. H8987-2, gift of the Supreme Court of NSW, 1972. cs

Jungle knife (parang latok) and scabbard
Kalimantan, Indonesia

The *parang latok* is a heavy jungle knife or sword, which is used with both hands. The scabbard is made from two pieces of wood held together with brass bindings and ornamented with tufts of hair and a curling motif reminiscent of those on Dayak textiles, beadwork and woodcarvings. Dayak means 'inland person' and is the collective name often used to describe non-Muslim ethnic groups of Kalimantan's interior.

Iron, wood, brass bound, hair, made by a Dayak man in Kalimantan, Indonesia, 1850–1900. 2.8 x 70.8 x 9.5 cm. H3062-1:2. cs

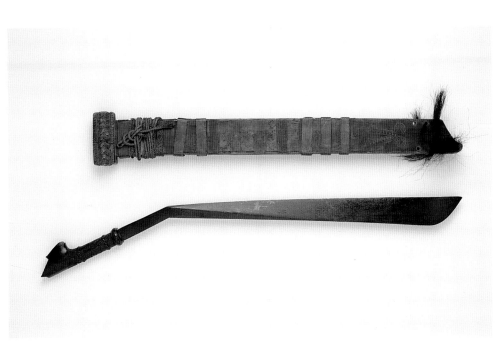

Sawankhalok bowl
Thailand

The technology for making green-glazed (celadon) wares was probably introduced to Thailand from China during the early 1300s. By that time, Chinese celadons were being produced in commercial quantities. Thai green-glazed wares, which closely resemble Chinese celadons of the Yuan (1279–1368) and Ming (1368–1644) dynasties, were exported in quantities to Java, Sulawesi and the Philippines.

Green-glazed stoneware, incised decoration, made at Sawankhalok (now Si Satchanalai), north-central Thailand in the 1300s or 1400s. 9.8 x 27.2 x 27.2 cm. A6614. CS

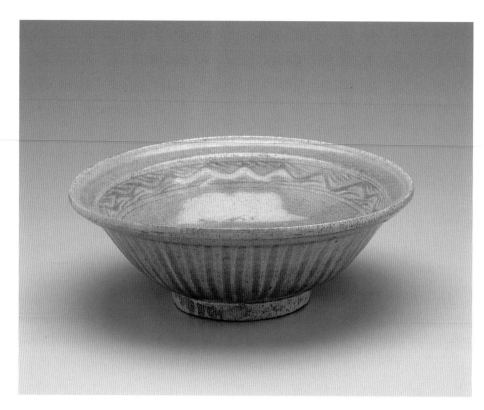

Khmer storage jar
Cambodia

This storage jar probably once held wine. In a twelfth-century temple relief at Banteay Chmar in northern Cambodia, people are shown drinking from a similar jar through straws while in an adjacent panel drunken dancers cavort. Khmer potters began producing dark-glazed wares like this one in the eleventh century, but the finest were not made until the mid twelfth century, contemporary with the building of Angkor Wat.

Stoneware, incised and glazed, made in Cambodia or present-day east Thailand, 1100s. 40.5 x 33.5 x 33.5 cm. A6615. CS

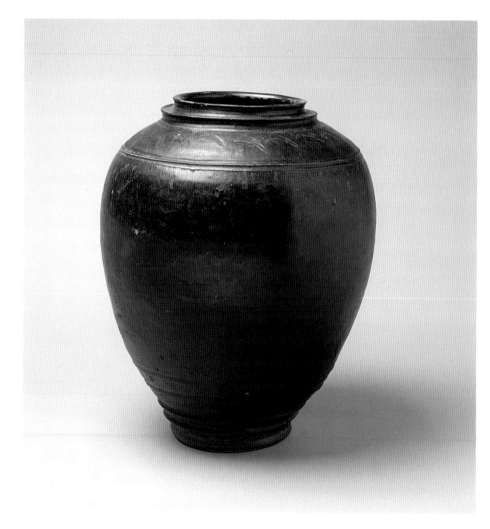

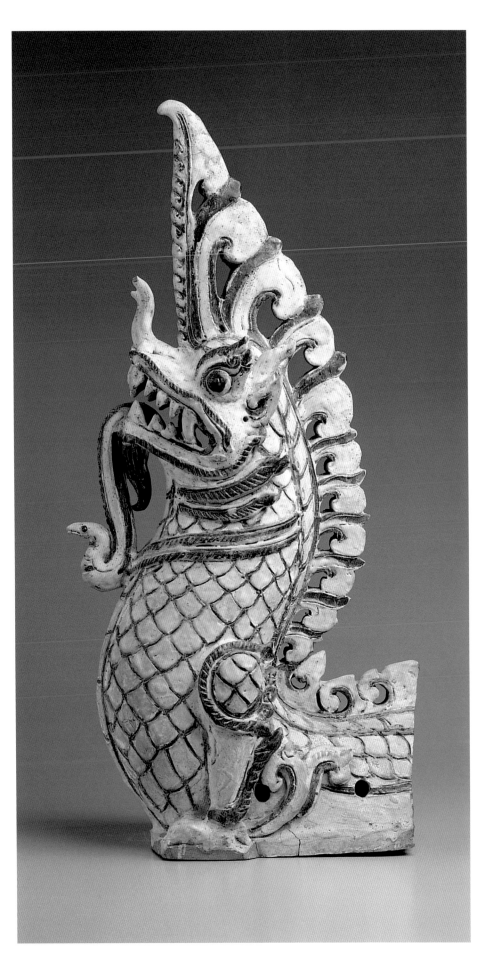

Sawankhalok roof finial
Thailand

This sculptural ornament once decorated the roof of an assembly hall in Sawankhalok. It takes the form of a *naga*, the mythical serpent-dragon that was both a protective spirit and a demon and occurs in art forms throughout Southeast Asia. The design was probably derived from decoration on Khmer temples built in Sawankhalok when the area was under Angkorian control between the tenth and thirteenth centuries.

Brown and white glazed stoneware, incised decoration, made at Sawankhalok (now called Si Satchanalai), north-central Thailand, 1400s. 58 x 18 x 27 cm. A6638. CS

Sawankhalok covered bowl
Thailand

Covered bowls like this one were probably intended for holding food offerings in a Buddhist society. They came in a range of shapes and were one of the main products of the newly developed above-ground cross-draught Sawankhalok kilns. The delicate plant-form designs imitate Chinese underglaze cobalt-blue trade porcelains, but the Thais used iron-black instead of cobalt.

Stoneware, underglaze black decoration, made at Sawankhalok (now Si Satchanalai) in north-central Thailand, 1300s–1500s.
15.9 x 16.3 x 16.3 cm. A6618. CS

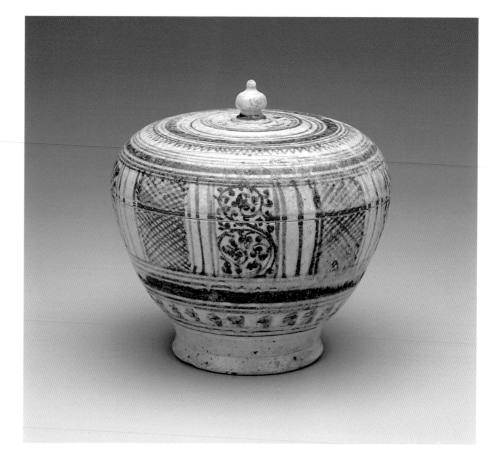

Sukothai covered bowl
Thailand

This ceramic bowl was made at Sukothai, which emerged as an independent provincial centre in the 1200s as the regional influence of Angkor diminished. The ceramic industry developed at Sukothai to serve the needs of the rapidly expanding city, and apparently began with the introduction of new kiln technology from Sawankhalok, 50 kilometres to the north.

Stoneware, dipped in white slip with underglaze black decoration, made at Sukothai in north-central Thailand, 1300s–1400s. 19.2 x 18.7 x 18.7 cm. A5302. CS

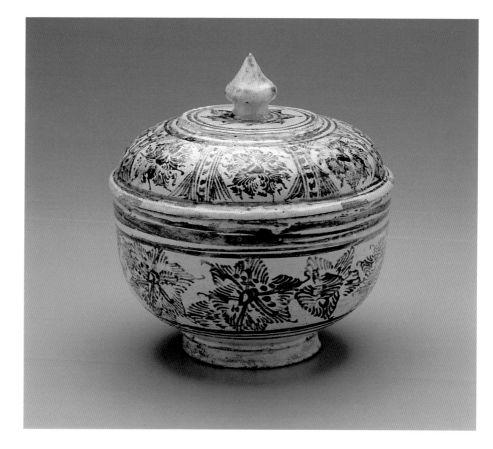

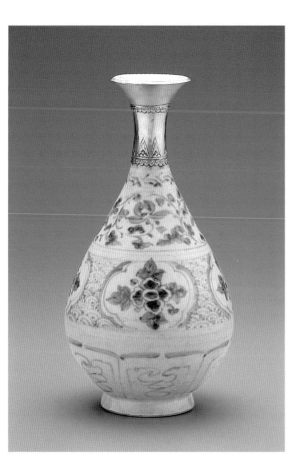

Silver-mounted bottle
Vietnam

Vietnamese potters produced great quantities of trade ceramics for export to Thailand, Indonesia and the Philippines from the 1300s to the 1500s. The range of shapes, techniques and designs were adapted from Chinese blue-and-white ceramic forms, although the painted designs have a distinctively Vietnamese fluidity. The silver mounting was added later to repair a break.

Stoneware, underglaze cobalt-blue decoration, made in north Vietnam, 1400s. 27.7 x 14.7 x 14.7 cm. A6616. cs

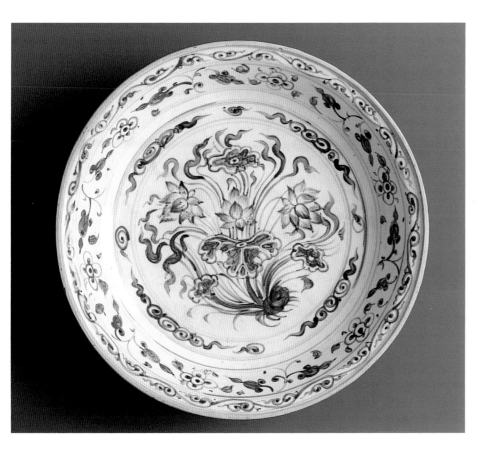

Large dish *(dĩa bằng đá)*
Vietnam

In the centre of this large dish is the lotus-pond design surrounded by cloud scrolls and flaming pearls, which is often found in 1300s Chinese blue-and-white ceramics. Vietnamese potters had achieved comparable mastery of underglaze cobalt blue techniques by the mid 1400s. Vietnamese ceramics are also known as Annamese, from *Annam* the Chinese name for Vietnam. Dishes like this one were produced for the export market.

Stoneware, underglaze cobalt-blue decoration, chocolate-brown iron wash on the base, made in north Vietnam, 1400s, 7.1 x 35.2 diam cm. A7285. cs

Bowl
Lombok, Indonesia

Recent international aid projects aimed at reviving, maintaining and developing local industries for economic survival have prompted the production of items such as this bowl. Although pottery is traditionally the preserve of women in Lombok, men are also involved in the initiatives. The bowl's burnished geometric design is typical of the region and also found on houses in Lombok.

Earthenware, hand-coiled and pit-fired, probably made in the village of Masbagik Timur, Lombok, Indonesia, 1996. 11.9 x 22.8 x 22.8 cm. 96/264/4. ME

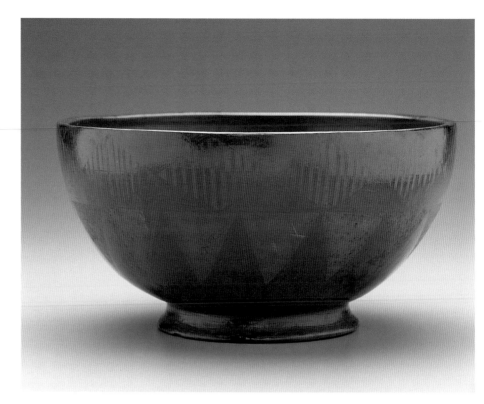

Bark container *(kepuk)*
Sumatra Indonesia

Simple boxes and baskets in a range of sizes were used by Karo Batak people in Sumatra to store household items. Larger bark boxes such as this one held clothing and jewellery. The containers themselves were kept in the roof or stacked against a wall in the living area.

Bark, leather twine, varnish, made by Karo Batak people in Sumatra, Indonesia, 1900–1920. 21.5 x 33 x 33 cm. A10993. ME

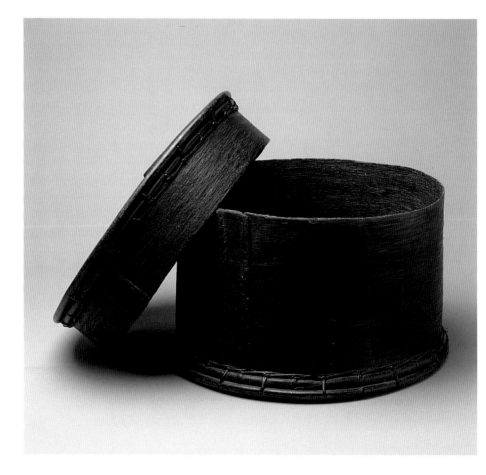

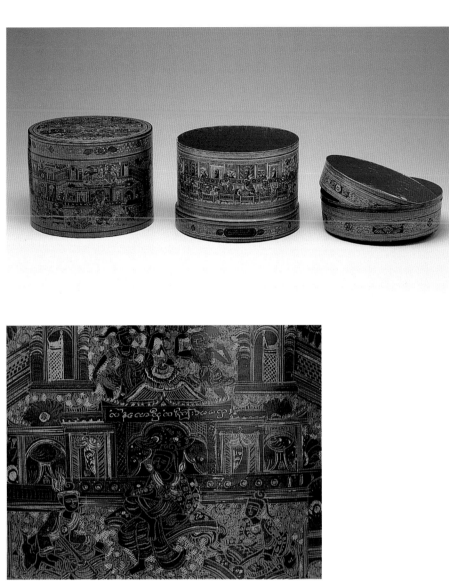

Lacquer betel box *(kun it)*
by Hsaya Gaung
Burma

Lacquer is one of the major artistic traditions of Burma. On this box, for storing betel leaves, tobacco, lime, cloves and areca nut, scenes from the *Ramayana* have been inscribed and coloured with tinted lacquer in the *yun* process (see detail). The *yun hsaya* (lacquer master) oversaw training and quality control in the workshop. His name is inscribed on the box together with 'original' and 'superior quality' in cartouches round the base.

Bamboo, lacquer with sap from *Melanorrhoea usitata* tree, made by Hsaya Gaung in Pagan, Burma, 1910–1930. 17 x 2.4 x 2.4 cm. A4201-1:4. CS

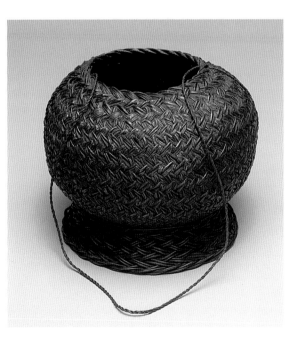

Basket
Lombok, Indonesia

This finely plaited basket is made from rattan or *rotan*. Durable as well as flexible, rattan is used throughout the Indonesian archipelago to create a wide variety of woven objects including mats, hats and baskets.

Rattan, twine, closed-plait weave, made in Lombok, Indonesia, 1900–1920. 18 x 21 x 21 cm. A10999. ME

Model Cambodian bullock cart and Vietnamese fishing boat
Thailand and Malaysia

These models were made by refugees from relatively recent wars in Cambodia and Vietnam. After the Vietnamese invasion of Cambodia in 1978, 200 000 refugees fled across the border into Thailand. This bullock cart was made in a refugee camp in Thailand. The fishing boat is of the kind used by Vietnamese 'boat people' and was made by Lai Duc, a refugee from north Vietnam, as he waited in Malaysia for entry into Australia.

Bullock cart: wood, bamboo, copper wire, string, made by a Cambodian in Thailand, about 1980. 17.9 x 45.5 x 24.3 cm, 98/178/5-2.

Boat: wood, glass, twine, metal, made by Lai Duc, Pulau Bidong Island refugee camp, Malaysia, about 1980. 35.3 x 63.5 x 17 cm, 98/178/3, gifts of the Indo-China Refugee Association, 1998. cs

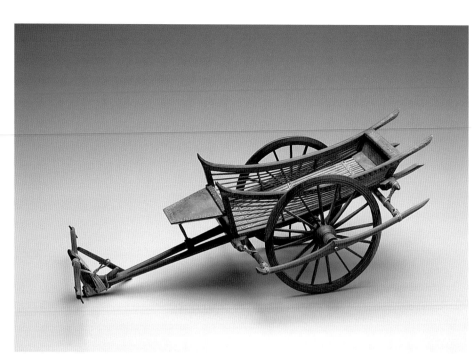

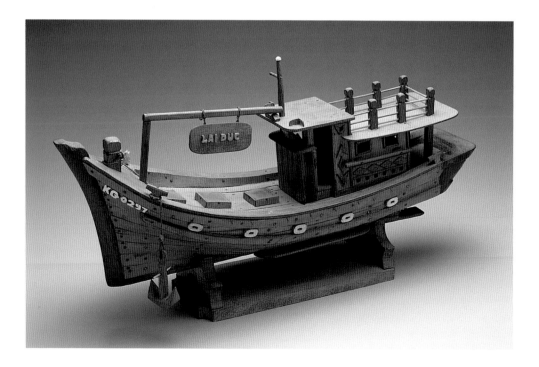

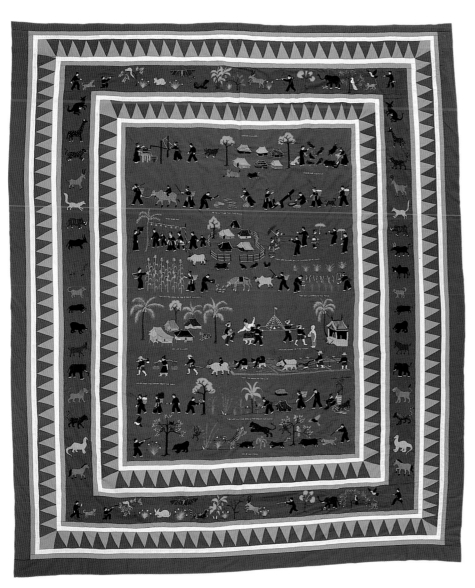

Story cloth by Mai Thoa
Thailand

Story cloths like this one were made by Laotian Hmong women and men in refugee camps in Thailand, where they fled to escape communist reprisals in 1976. Unlike traditional Hmong embroidery these cloths are all narrative works, portraying scenes from everyday life in Laotian villages (detail below). Story-cloth production was a commercial enterprise, and was also a means to inform the international community about Hmong culture and history.

Synthetic cloth, long-stitch embroidery, made in Thailand, 1983–1985.
253.5 x 215.5 cm. 86/705. cs

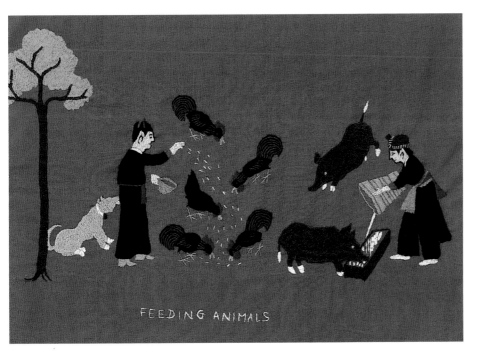

FEEDING ANIMALS

Tube zither
Mindanao, Philippines

The tube zither is made from hollow bamboo. The strings are cut from the length of the instrument but are not detached from it. Instead they are mounted at the ends over small bridges. The resulting slits under each string assist the sound production. The tube zither is used throughout the Philippines in small ensembles and to accompany songs. It is known by a number of different names depending on the cultural group and the region.

Bamboo and beadwork, made in Mindanao, Philippines, 1960–1980.
57 x 10.5 x 10.5 cm. 94/3/1. ML

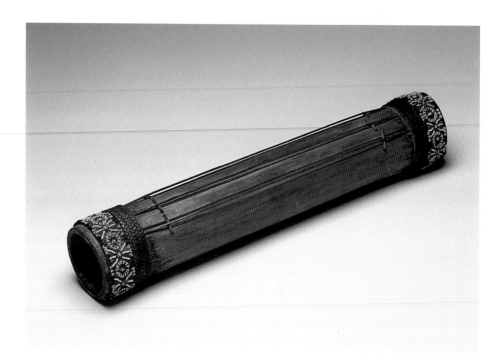

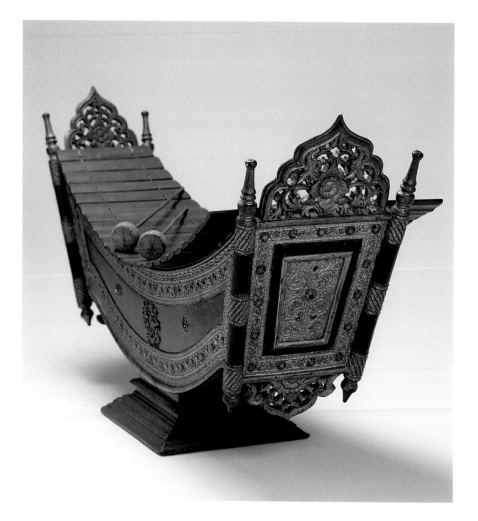

Xylophone *(pattala)*
Burma

This instrument is one of a number of xylophone-type instruments found throughout Southeast Asia. A series of 25 pitched bamboo bars are suspended over a boat-like soundbox often made of a hardwood such as teak. It is used in small ensembles and as a melodic instrument to accompany singers. A paste made from beeswax and lead shavings is often applied under the keys to tune the instrument or improve the tone.

Timber, bamboo, glass, paint and gilt, made in Burma, 1900–1940.
61 x 117 x 42.5 cm. H8994. ML

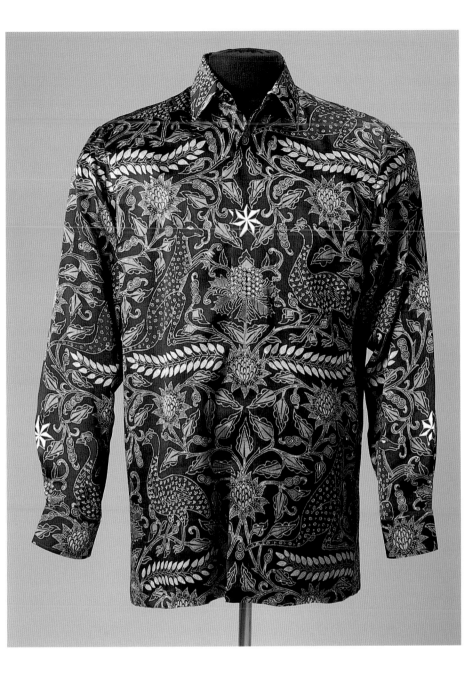

Shirt by Iwan Tirta
Java, Indonesia

Prominent contemporary batik designer Iwan Tirta was commissioned to design shirts for the 18 leaders attending the Asia Pacific Economic Cooperation (APEC) leaders meeting in Indonesia in November 1994 by the then Indonesian president, Suharto. This shirt was presented to the Australian prime minister at the meeting, The Hon P J Keating. The shirt features the Australian coat of arms (see detail).

Synthetic cloth, batik, made in Jakarta, Java, Indonesia, 1994. 85 (centre back) x 158 (cuff to cuff) cm, REC 9887/1, lent by The Hon P J Keating, 2001. ME

Bibliography

Brown, R. *The ceramics of South-East Asia: their dating and identification*, 2nd edition, Oxford University Press, Singapore, 1998.

Chin, L and Mashman, V. *Sarawak cultural legacy: a living tradition*, Society Atelier Sarawak, Kuching, 1991.

Frey, E. *The kris: mystic weapon of the Malay world*, Oxford University Press, Singapore, 1988.

Gittinger, M (ed). *To speak with cloth: studies in Indonesian textiles*, University of California, Los Angeles, 1989.

Gittinger, M and Lefferts, H L Jr. *Textiles and the Tai experience in Southeast Asia*, Textile Museum, Washington DC, 1992.

Groslier, B-P. *The art of Indochina: including Thailand, Vietnam, Laos and Cambodia*, Crown, New York, 1962.

Hall, D G E. *A history of South-East Asia*, 4th edition, Macmillan, London, 1981.

Isaacs, R and Burton, T R. *Visions from the golden land: Burma and the art of lacquer*, Art Media Resources, Chicago, 2000.

Jacques, C. *Angkor*, Konemann, Cologne, 1999.

Maxwell, R. *Textiles of Southeast Asia: tradition, trade and transformation*, Oxford University Press, Melbourne and New York, 1990.

Osborne, M. *Southeast Asia: an introductory history*, 8th edition, Allen & Unwin, Sydney, 2000.

Rawson, P. *The art of Southeast Asia*, Thames and Hudson, London, 1990.

Richards, D. *South-East Asian ceramics: Thai, Vietnamese, and Khmer: from the collection of the Art Gallery of South Australia*, Oxford University Press, Kuala Lumpur, 1995.

Richter, A. *The jewelry of Southeast Asia*, Thames and Hudson, London, 2000.

Rodgers, S. *Power and gold: jewelry from Indonesia, Malaysia, and the Philippines*, Barbier-Mueller Museum, Geneva, 1985.

Steinberg, D J (ed). *In search of Southeast Asia: a modern history*, revised edition, Allen & Unwin, Sydney, 1985.

Taylor, E. *Musical instruments of South-East Asia*, Oxford University Press, Singapore, 1989.

Taylor, P M and Aragon, L V. *Beyond the Java Sea: art of Indonesia's outer islands*, Smithsonian Institution, Washington DC, 1991.

Warren, W and Tettoni, L I. *Arts and crafts of Thailand*, Thames and Hudson, London, 1994.

Wolters, O W. *Early Indonesian commerce: a study of the origins of Srivijaya*, Cornell University Press, Ithaca NY, 1967.

About the authors

Milton Osborne has had an association with Southeast Asia since being posted to the Australian embassy in Phnom Penh in 1959. He completed his doctorate in Southeast Asian history at Cornell University and has held academic appointments in Australia, Britain, Singapore and the United States. A consultant to the United Nations High Commission for Refugees in 1980–1981, he was head of the Asia branch of the Australian government's Office of National Assessments 1982–1993. Now a full-time writer and consultant on Asian issues, he is the author of eight books on the history and politics of Southeast Asia including *Southeast Asia: an introductory history* (Allen & Unwin, 2000, 8th ed) and *The Mekong: turbulent past, uncertain future* (Allen & Unwin, 2000). He is currently a Visiting Fellow in the Faculty of Asian Studies at the Australian National University in Canberra.

Christina Sumner is a curator of decorative arts and design at the Powerhouse Museum, specialising in traditional textiles and textile technology. She is the curator of the exhibition *Trade winds: arts of Southeast Asia*. Christina was editor/author of *Beyond the Silk Road: arts of Central Asia* (Powerhouse Publishing, 1999), coordinating author of *A material world: fibre colour and pattern* (Powerhouse Publishing, 1990), and has contributed to a variety of other publications including *Flowers of the loom: plants, dyes and oriental rugs* (Oriental Rug Society of NSW, 1990), *Decorative arts and design from the Powerhouse Museum* (Powerhouse Publishing, 1991) and *Heritage: the national women's art book* (An Art & Australia Book, 1995).

Illustration captions*

Paul Donnelly (PD) is a curator of decorative arts and design at the Powerhouse Museum, specialising in numismatics and archeology.
Melanie Eastburn (ME) is a curator of Asian decorative arts and design at the Powerhouse Museum. Her research interests span contemporary Asian art, Balinese embroidery, Central Asian costume and printmaking in Papua New Guinea.
Michael Lea (ML) is the curator of music and musical instruments at the Powerhouse Museum.
Christina Sumner (CS)

* Authors note: Translations which follow the title of an object are either literal or the term/s used in the country of origin.

About the Powerhouse Museum

The Powerhouse Museum is Australia's largest museum. Part of the Museum of Applied Arts and Sciences established in 1880, the Powerhouse Museum was purpose-built in 1988. Its collection spans decorative arts, design, science, technology and social history, which encompasses Australian and international, and historical and contemporary material culture. The Powerhouse Museum has a reputation for quality and excellence in collecting, preserving and presenting aspects of world cultures for present and future generations. In 1997, the museum opened its Asian Gallery to promote a greater awareness and appreciation of Asian cultures in Australia.